DISCOVERING
AFRICAN
ART

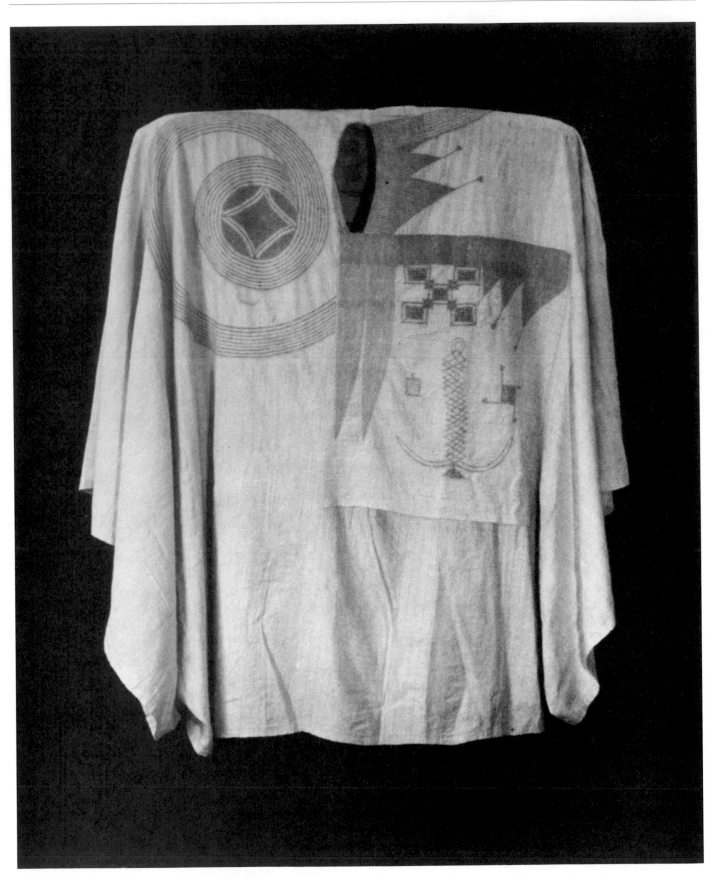

Hausa people, Nigeria, *Man's Robe (Agbada)*, Cotton. 56" x 105 1/2" (142.2 x 268 cm). Gift of the Honorable Joseph Palmer, II, National Museum of African Art. Photograph by Franko Khoury.

DISCOVERING AFRICAN ART

Jacqueline Chanda

Davis Publications, Inc.
Worcester, Massachusetts

Preface

Acknowledgements

I would like to give special thanks to the staff at the National Museum of African Art. Many thanks go to other museums and galleries that contributed and granted permissions for the use of their photographs. I am indebted to Marilyn Heldman for her helpful information and expertise on Ethiopian painters and their art, and to Olubunmi Adejumo and Amir Nour for their patience and understanding and for allowing me to feature their works in this book. Finally, I am very grateful to friends, colleagues, and graduate students at the Ohio State University who allowed me to bounce ideas off them. These include: Vesta Daniel, Don Killeen and Bryan Grove. My thanks also goes to The Ohio State University for granting me funding to the initial research for this book.

My aim and objective in writing this book has been to present African art in a manner that would allow the reader to reconsider previously held assumptions and existing notions and to consider future possibilities. Eighteen objects were chosen to represent African artists who worked at different time periods, used very diverse materials and came from different ethnic groups and geographic locations. The objects range in date from as early as the fifteenth century to the present. The artworks incorporate the use of more traditional media such as wood, clay, metal and beadwork, as well as more contemporary materials such as steel and techniques such as printmaking.

Although a large number of the objects come from well known ethnic groups such as the Yoruba of Nigeria and the BaKongo of Angola and Zaire, an effort has been made to discuss works of art from a variety of ethnic groups. Consequently works from little known groups such as the Mijikenda of Kenya or the Ndebele of South Africa are included.

An effort has also been made to show the breadth of African artistic production. The artwork originates from the south, west, east and central parts of Africa. Objects range from clay vessels, wooden masks and statues, to beaded aprons and crowns. While readers are exposed to an expanded view of African art, they also have the opportunity to take a more in-depth look at common contextual settings.

Printed in U.S.A.
Library of Congress Catalog Card Number: 96-083459
ISBN: 087192-306-8
10 9 8 7 6 5 4 3 2 1

Publisher: Wyatt Wade
Editorial Director: Helen Ronan
Production Editor: Nancy Bedau
Production: Steven Vogelsang
Copyeditor: Frankie Wright
Editorial Assistance: Jane Boland and Colleen Fitzpatrick
Design: Douglass Scott, WGBH Design

COVER: Yoruba people, Nigeria, *Efe/Gelede Mask*. Wood, pigment, cloth, iron, metal, foil, H: 28 5/16", (71.9 cm). Indianapolis Museum of Art. Gift of Harrison Eiteljorg.

Contents

Topics were chosen to emphasize these commonalities and to show the wide range of approaches to the study of African art. Each topic or chapter includes two works of art which enable the reader to compare and contrast representations and ideas from two different regions in Africa.

Comparisons also have been made with art from world cultures in order to show differences and similarities among cultures of the world.

The suggested classroom activities are designed to help students explore different aspects of art and consequently contain elements of art history, aesthetics, criticism and production. Some of the activities move the discussion and explorations beyond the boundaries of the text engaging students in critical thinking exercises.

It is my hope that this book will provide multiple avenues for exploring, discovering and understanding African art in context.

Jacqueline Chanda
January 1996

Introduction

The World of African Art

"African art" is the label usually given to the visual arts of the peoples who live south of the Sahara. But like "European art" or "Native American art," the term misleadingly lumps together many distinct cultures. The commonalities that have joined people on the African continent and shaped the aesthetic visions of individuals and groups of people are related to their beliefs, ideas and historical events.

Traditionally, works of art were carvings, metal castings, clay sculptures and weavings. They were embellished to invest them with special powers or simply to enhance them aesthetically. Decorations with incised geometric patterns, beads, cowrie shells, skin, horns, cloth, feathers, jewelry and strips of metal were typical.

Those objects which today are classified as African art were at one time considered cultural artifacts to be studied and exhibited along with the flora and fauna of a particular region. Anthropologists studied these artifacts as cultural products that revealed information about the social structure and kinship relationships. It was not until the advent of European modern art of the early twentieth century that African artifacts began to be viewed and appreciated as aesthetic objects. In an effort to create an aesthetic that was more appealing to the European audience, objects were stripped of their skins, cloth, jewelry and feathers. They were polished and displayed in cases.

Many of the objects that Westerners call works of art are, to Africans, aesthetic objects meant to perform a particular task or to cause a particular action or reaction to take place. In many African cultures, if an object is aesthetically pleasing it is "good." And if it is "good" it works. An object can not work if it is not pleasing to the eye.

Some ritual and secular objects were preserved as the Ndop statues of the Kuba people of Zaire. However, others such as the grave posts or kikangu of the Mijikenda people of Kenya were destroyed or allowed to decay. The preservation or the destruction of an object depended greatly on its purpose. For example, if the object served as an offering to an ancestor spirit, it might be allowed to decay. On the other hand, if the object has a truly commemorative or guardian nature it might be preserved, cleaned and repainted.

Like art of the European Middle Ages, African art has served religious purposes. It still does today. Like the aesthetic conventions of the European Rococo period, African art, too, has been made for personal decoration and to decorate the environment. It has honored individuals and elevated pride, shown power and prestige. And like contemporary Western art, it can reflect the personal desires or ideas of individuals.

In their traditional context, African art objects were not put on display on a regular basis for everyone to observe and admire. Generally, objects were displayed in the open only during festivals, ceremonies and rituals. When not in use, some were kept in special places and cared for by chosen people. Today, the Chokwe of Angola keep their community masks in a small hut in the forest. These masks are looked after by a caretaker. There are numerous other examples in which art objects are made, used, displayed and stored in traditional ways. Nevertheless, art museums are present in many African countries.

Traditional and contemporary works of art are displayed for the admiration of all. The National Museum of Zaire, located in Kinshasa, is only one of many examples.

The African Artist

There are many misconceptions about African art and artists. Some artists actually express themselves unconsciously and instinctively through dreams and spiritual visions. In general, though, artists make well-designed objects to enhance social and spiritual events. The experience of the event becomes "better" when an art object is well executed. Artists make objects for different, often overlapping reasons. Besides creating beautiful objects to enhance their lives, the impulse to create stems from wanting to earn a living, and to acquire wealth or gain prestige.

Traditionally, artists learned their trade in an apprenticeship system. Children aged seven and older learned an art form by observing accomplished artists. Apprentices copied the techniques of the "master," heeding the advice, criticisms, and praises. When the apprentice was good enough he or she received goods, such as food or animals, as pay for their artistic services. The apprentice system continues today, but many artists also learn their trade through formal training at schools.

Materials and Methods

African artists, past and present, have used many materials for their art. They carve in wood, ivory and stone. They model clay and mud, cast in metal, weave and embroider cloth, produce beadwork, and paint.

Wood carving was and still is considered to be the most widespread art form. Wood is carved with an

adze which is a small axe with an arched blade at right angles to the handle. Finishing touches are added by a knife or other small implements. The wood is generally carved when freshly cut and "green." To protect the carvings from termites, artists polish them with a mixture of soot and grease, or place them in a mud-bath for a few days. Or it may be treated with sap from roots and leaves or with fine camwood powder. Sometimes, artists blacken their carvings with the smoke and dust from the fire. Most sculptures are made out of a single piece of wood, so that the form of the tree remains tangible and recognizable, but there are sculptures in which multiple pieces of wood are assembled, as in some Gelede masks from the Yoruba of Nigeria.

Stone carvings are scarce in Africa but examples can be found from ancient Ife, Zimbabwe and parts of central Africa. Artists worked with a variety of stones — granite, gneiss, basalt, quartz, limestone, sandstone and steatite, a talc-type soapstone. Steatite has been the most commonly used. It is quarried from riverbeds and while still wet, it is soft and as easy to carve as wood.

Clay sculptures can be found throughout Africa but they are often delicate and in some places can be rare. Ancient ones have survived from the Nok, Niger Basin, and Ife cultures. Works in clay from the Cameroon grasslands are in the form of tobacco pipes, and among the Mangbetu and the BaKongo, in the form of figure-shaped vessels. Earthenware vessels are molded freely by hand, without the use of a potter's wheel. The potter creates a vessel either by scooping out a lump of clay or by building up coils of clay into a pot shape, which is then made

smooth. Pots are dried in the shade for several days and finally baked for a short time in a wood fire. They are then treated with vegetable solutions to reduce the porosity.

African crafts people have used many kinds of metal-iron, bronze, brass, gold and copper. The use of iron in Africa dates back to 400 B.C. for knives, arrow heads and ceremonial axes. Brass and bronze casting, using the lost wax method, was known in Ghana as early as the 9th century. For this technique, casters model a figure in wax around a clay core and add a coating of clay over the wax. The whole is heated, the wax melts, and the core is filled with molten metal. The core of clay is broken up and the artist finishes the piece by polishing, engraving and filing it.

Embroidery is a decorative application of thread to an already existing garment. In West Africa embroidery is generally the work of men; in Central Africa women embroider as well. The largest number of embroiders come from countries such as Mali, Northern Nigeria, the Sudan and Niger. The techniques and patterns of embroidery found in West Africa show some Moslem influence.

Excellent examples of beadwork can be found in parts of Nigeria, Cameroon, and South Africa. In West African cultures, beadwork artists are male; in South Africa they are female. Beads traditionally were a trade item that symbolized prestige and wealth. Africans made their beads out of bone, and ivory until they began trading with Europeans for glass beads.

Painting is another art form that is not foreign to Africa south of the Sahara. Women did most of the

painting on mud walls, and cloth. In Ethiopia, men painted Christian imagery on plastered walls. In West Africa, artists painted the wood sculptures they carved. Paints were made from local pigments, such as soot, clay, indigo and camwood. The red, black, white, yellow and blue palette was often limited. Some artists mixed their pigments with binders that produced enamel-like colors. Today many artists purchase commercially made acrylic paints or enamel paints, and they paint on surfaces such as canvas or board.

Many present-day artists use other nontraditional media and materials. They combine various techniques to produce innovative forms of art used for either traditional or new purposes. African art has constantly evolved and changed over the centuries and it continues to do so.

This book does not attempt to provide a comprehensive view of African art. A range of objects has been selected, spanning vast time periods and covering a variety of media. These objects can enlighten us as to the beliefs and aesthetic concerns of many African peoples, past and present. But the complexities of historic time, place, and culture cannot be easily reduced to brief discussions of single objects. Therefore, whenever possible, build an understanding of the rich contexts from which art objects are made, used and appreciated. Seek out additional resources, and more important, locate objects in museums or collections to view in person.

African Timeline and Map

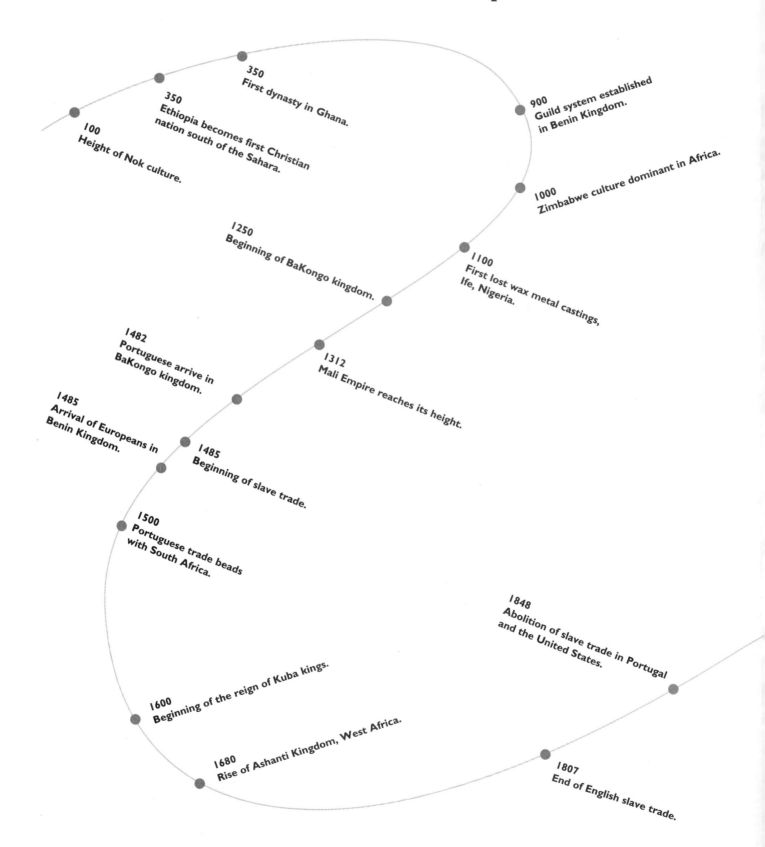

100
Height of Nok culture.

350
Ethiopia becomes first Christian
nation south of the Sahara.

350
First dynasty in Ghana.

900
Guild system established
in Benin Kingdom.

1000 Zimbabwe culture dominant in Africa.

1250
Beginning of BaKongo kingdom.

1100
First lost wax metal castings,
Ife, Nigeria.

1482
Portuguese arrive in
BaKongo kingdom.

1312
Mali Empire reaches its height.

1485
Arrival of Europeans in
Benin Kingdom.

1485
Beginning of slave trade.

1500
Portuguese trade beads
with South Africa.

1848
Abolition of slave trade in Portugal
and the United States.

1600
Beginning of the reign of Kuba kings.

1680
Rise of Ashanti Kingdom, West Africa.

1807
End of English slave trade.

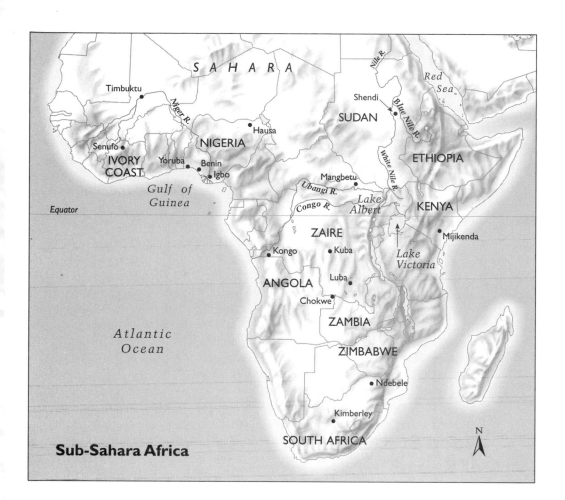

Sub-Sahara Africa

This map shows major African cultural groups and sites mentioned in this book.

1850
William Sheppard visits Kuba Kingdom.

1867
Diamonds discovered, Kimberley, South Africa.

1931
First trans-Africa railway completed from Angola to Mozambique.

1951
Ghana first country to gain independence.

1980
Zimbabwe independence.

1992
Apartheid abolished in South Africa.

1994
Nelson Mandela elected President of South Africa.

Kuba King Statue

The Kuba Artist

THE Kuba people live in central Zaire. Historically, Kuba artists were professional wood-carvers, blacksmiths, and weavers who worked exclusively for the king. Kuba wood-carvers carried a decorative adze (a small ax used for carving) on their shoulders as a sign of honor, because wood carving was a highly valued, specialized, and respected profession. In general, artistic talent, called *mentsi*, was respected to such a degree that many of the kings were carvers or artists of some sort.

Kuba artists learned their craft by becoming apprentices to others who were well-known and accomplished. Similar to art traditions in other world cultures, the apprentices imitated early pieces and then developed their own designs.

Ndop statues were one of the more revered Kuba art forms. These two-foot tall wood carvings of the ruling kings probably served as commemorative portraits. They were said to be kept at the court of Mushenge, the capital city in the Kuba Kingdom, by surviving wives, in remembrance of the dead king. The statues possibly served as the king's "spiritual" double in his absence.

One tradition suggests that the statues were carved while the kings were still alive. Once carved, the portrait was hidden. When the king felt that his end was near, he had himself shut up with his statue so that it should take up his last breath. The new king then spent his first night as king with the statue of his predecessor. In this way the portrait figures were said to transmit sacred power from one king to the next. Myth also has it that when the king died, the sculptor who had carved his Ndop was buried alive head-first as a sacrifice.

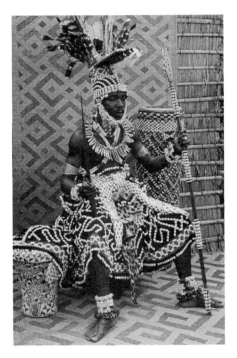

Kuba Nyim (King) Kot a Mbweeky III on state visit to a village in Zaire. Kot a Wbweeky has been ruling since 1969. He wears the bwaantshy which is a ceremonial costume that weighs almost 185 pounds. Photo by Eliot Elisofon, 1970 Eliot Elisofon Photographic archives, National Museum of African Art.

Ndop Statue of Kuba King

Ndop statues flourished as an art form in Zaire from the eighteenth to the early twentieth century, and the style of the statues is unique in Kuba culture.

Look closely at the Kuba King statue shown here. Notice the king's posture, the demeanor, and the royal accoutrements. Important cultural conventions guided the artist's decisions in making the piece. The expression on the face, the position of the body, and the costume were meant to faithfully represent the ideal of king—but not an individual king. For example, the facial features of each statue follow carving conventions and do not represent features of a specific individual. In the statue shown here, the features are typical of those carved in the early part of the eighteenth century. How would

you describe the expression? The semi-closed eyes give the figure a serene look, an almost spiritual appearance.

Ndops are distinguished one from another by an *ibol,* which is an object carved in full *relief* and attached to the front of each statue's base. This insignia identifies the reign of an individual king. On this statue, locate the ibol, which is a royal drum.

What style or conventions did artists follow? The Ndop statues are represented as cross-legged male figures, seated on a decorated base with the right hand placed on the right knee, and the left hand holding a royal knife or dagger, which is a symbol of power. They wear a martial ceremonial costume that includes a *cache-séant,* which is a garment that protects or hides part of the body, and beaded and knotted belts. The base can be rectangular, square, or circular, and its surfaces are

decorated with a *motif* the king chose or designed at the time he was throned.

Using an adze, artists carved each statue out of a single redwood block. Details were worked with a chisel or a knife. Once completed, the sculpted piece was finished in one of two ways. One was to rub it with redwood powder and palm oil and then smoke it over a fire; the other, to wash it with a vegetable dye that darkens the surface of the wood. These methods were probably intended to preserve the wood.

The statues showed what kings conventionally wore: a royal headdress adorned with *cowrie shells,* a wide cowrie shell belt, and a belt made of fiber and beads. The headdress was a sign of prestige and authority, and the fiber belt symbolized one who is able to keep state secrets. Such a belt was worn by the king and other notables who had earned the privilege.

The king's fiber and bead belt is indicated on the statue by the knotted belt below the navel. Notice how the statue includes a motif on the headdress that indicates cowrie shells. (Actual cowrie shells are white and oval-shaped and can be seen in the photo of Nyim Dot a Mbweeky III.)

Artists decorated the statues by carving representations of jewels, bangles, and other objects such as anklets, armlets, and bracelets. Each object represented the power and authority of the king. Find armlets carved into the upper arms of the statue. These correspond to the

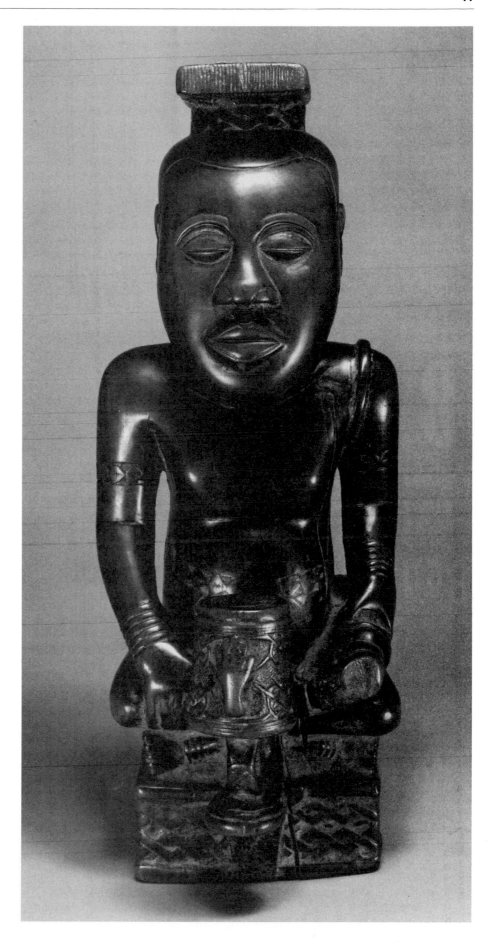

The mortar board or visor-like headpiece that the statue is wearing corresponds to the shody, a hat worn by the king for spiritual purposes. Zaire, *Ndop of King Misha mi-Shyaang a-Mbul,* c. 1650. Wood, H: 19 3/8", (49.2 cm). Brooklyn Museum, New York.

wide metal armlets worn by a king and his sons during ceremonial occasions. These armlets had an embossed, or raised, design engraved on them.

Early figures were traditionally carved in a one-to-three proportion. The head of the statue was carved to be one third the size of the total statue. The Kuba artists emphasized the head because its was considered the seat of intelligence and the spiritual force.

Examine how the statue sits on a rectangular box with an interlaced pattern engraved on its sides. The royal drum, as the ibol, is said to represent King Misha mi-Shyaang a-Mbul. Why do you think the statue has a shiny surface? When wood is handled over many years it can become smooth and shiny. The statue may have been polished or rubbed frequently.

The first record of the existence of Ndop statues came from the notes of William Sheppard, an African-American missionary who visited the Kuba Kingdom in the late nineteenth century. Seventeen Ndop statues were exhibited in Belgium in 1937. At least thirty-four have been found to date, although some may be fakes. The most recent Ndop statue was made in 1969 and was carved by the king himself, King Mbope Mabiintshi ma-Kyeen.

World Art Connections

● In early sixteenth-century Germany, artists such as Hans Holbein were noted for their attention to exact detail. In the same manner, Kuba artists seem to have been very concerned with exact details. Both Hans Holbein and the Kuba artists were court artists. Their major job was to provide portraits of royalty. Hans Holbein's paintings have been praised for providing a realistic image of sixteenth-century aristocratic clothing, hair styles, and general appearances. This may not have been his intention, however, when he made his paintings. Kuba sculptures have been valued for providing clues to the ceremonial dress and regalia of the eighteenth-century Kuba kings.

● Locate a reproduction of the **mosaics** in the church of San Vitale in Ravenna, Italy. These mosaics are of the Byzantine period, an extraordinary cultural outpouring of art and architecture which began in 527 AD, after the decline of the Roman empire. Emperor Justinian, whose reign marked the beginning of the Byzantine Golden Age, was depicted in a San Vitale mosaic. He is shown with a halo, indicating that he was the Christian God's holy representative on earth. In the Kuba culture, the king was also considered to be God's representative, and was called God of the Earth. When looking at the mosaic in San Vitale, the people were reminded of the unique spiritual position of the emperor, just as the Ndop statues reminded the Kuba people of the unique spiritual position of their king.

Classroom Connections

● Do you think the Ndop statues can be considered true likenesses of the kings, even though the facial features were carved to be generic? Do these portraits represent general notions of the Kuba kings or do they represent real Kuba kings? Think about the definition of portrait. Write down your views and discuss them with a partner. Then work together to find examples of both a conceptual portrait and an actual portrait from other cultures.

● Study Kuba ceremonial dress by comparing the Kuba king statue with the photograph of a present-day Kuba king. Locate other examples of Ndop statues. Determine which elements have been retained and which have been eliminated. What might be the significance of each object of the king's regalia? Then find other examples of Kuba wood carving, metalwork, and weaving. Do you notice any design features common among these art forms?

The ibol in the front of the statue in the photograph represents a drum called *pel ambish*, the drum of reign. The entire surface of this drum is profusely decorated with copper, cowries and beads. The *pel ambish* is not played but accompanies the king in important ceremonies.

The most famous of the Kuba kings, Shamba Bolongongo, ruled at the beginning of the seventeenth century. It is said that he summoned accomplished sculptors to his kingdom and inaugurated the tradition of ndop statues.

- The Kuba statues include many sculptural "textures" because of the many different decorative patterns employed to create likenesses of objects from real life. Textures found on sculptures may have been inspired from items found in everyday life. Explore the photograph of the Kuba statue and note as many textures as you can. Make drawings of them. Looking at resources on Kuba art, compare your drawings with images of objects from Kuba culture. Discover as many relationships as possible between the textures created on the statue and images from real life.

Study Sheet

1 When were Kuba King statues carved? Why?

2 What was special about the artists who carved them?

3 What is an ibol? Why is it an important feature of an Ndop statue?

4 Why are Ndop figures carved in a one to three ratio?

5 In what ways do the costume and adornments on the statue match a real-life king's regalia? In what ways are the statues' costumes different?

Resources

Museums
Brooklyn Museum of Art, Brooklyn, New York

Metropolitan Museum of Art, New York, New York

University of Iowa Museum of Art, Iowa City, Iowa

Books
Cornet, J. Art Royal Kuba (Royal Kuba Art). Milan: Edizioni Sipiel, 1982.

Rogers, D. Royal Art of the Kuba People. 1979.

Vansina, J. A History of the Kuba Peoples: The Children of Woot. Madison: University of Wisconsin Press, 1978.

Vansina, J. "Ndop: Royal Statues Among the Kuba." In Fraser, D. and Cole, H.M., eds. African Art and Leadership, Madison: University of Wisconsin Press, 1972.

Zeidler, J. & M. L. Hultgren. Art/Artifact. New York: The Center for African Art, 1989.

Articles
Adams, M., "Eighteenth Century Kuba King Figures," African Arts (Los Angeles): 31–38.

Rosenwald, J. B., "Kuba King Figures," African Arts, vii(3): 26–31, 1979.

Benin Heads

The Craft of Brass Casting

BRASS CASTING was well known to the Old World of Africa. It was used for making art, particularly sculpture and jewelry, from Senegal on the Atlantic coast to Lake Chad on Nigeria's northeastern border.

As early as the 1400s, the Benin people of western Nigeria cast brass heads of *obas*, or kings, using the *cire perdue*, or lost-wax method. Have you ever made a mold of an object so that it could be copied, using a more permanent material? In the lost-wax method, an artist sculpts an object in clay to create a mold for a metal reproduction. For the Benin head, the African artists made the head in clay, which they dried in the sun, and then they melted wax, poured it over the clay model, and smoothed the wax with a knife. Details such as eyebrows, mouth, ears, chin, hair, and beard were shaped in wax and attached with a hot knife. Then a coarse clay was layered over the wax, leaving only a small hole or duct. Visualize how the artist created a mold for the metal sculpture. Imagine a cross-section of the model with its clay-wax-clay layers.

After the entire clay mold dried, it was heated so the wax inside could melt, drip out, and make way for molten brass. Brass is a mix of copper and small amounts of other metals. When combined in a very hot fire, the metals melt together, creating an alloy that is stronger and more malleable than copper alone for casting durable objects.

The heated mold was then placed in the ground and molten brass poured into the duct. When cooled, the inner and outer clay was broken off to reveal the hollow brass sculpture, which was then cleaned, filed, and polished smooth.

The artists of Benin Kingdom were part of a guild system, which dated from about 900 AD. This date corresponds closely to the beginning of brass casting in Benin. The guild system guaranteed a standardized high quality of products for the oba, who, as king, owned all of the brass. Artists worked in an association, or guild, whose chief acted as an intermediary between the artist and the oba. The job of the brass casters was to portray the glory and power of the court, and these artisans were highly venerated in the royal community.

Benin Brass Heads

In the Benin Kingdom, the use of brass was limited to the highest social class and demonstrated the power and wealth of the court. Brass fulfilled special ceremonial needs and represented the stability of the ruling order. The most important patron of brass sculptures was the oba.

Benin brass heads are portraits of the obas. However, the features do not necessarily reflect the actual features of individual kings. Instead, different head types or styles reflect time periods and political and social changes in the Benin Kingdom. Exact dates for the Benin heads are difficult to determine, but they can be divided into representative time periods.

The earliest-known Benin heads were cast before the arrival of Europeans in 1485. They are delicate castings with very thin walls. Examine the Oba sculpture in *Figure 1*. Do you notice that something appears missing? Iron inlays were originally placed in the eyes and in the two parallel strips on the forehead. The hair is represented by parallel rows, and a collar of beads, imitating actual coral beads, hugs the neck. *Scarification* marks appear over the eyes. Some historians speculate that the concentric-ringed hair and the scarifications indicate a male foreigner. If so, these early heads could represent trophies of war.

Benin head castings of the seventeenth and early eighteenth centuries display high collars that cup over the chin. These heads are larger and heavier and include a beaded lattice-work net with rosettes covering the head. Long strands of coral beads hang over the temples to the base of the neck. The cheeks are shallow and the eyes are large. Over 160 of these sculptures survive. During this period we also find brass heads of the Benin Queen Mother. These heads are similar to

those of the kings, but have conical head coverings.

The oba heads cast during the mid-eighteenth and early nineteenth centuries had a commemorative function (see *Figure 2*). These castings share many of the same characteristics as those of the previous period. One of the main differences, however, is the protruding ridge or flange surrounding the lower section of the head. The ridge typically includes relief images of human heads, kola nuts, and other royal symbols, or of animals, such as leopards, elephants, and mudfish. Notice the slightly bent

rods of beads that reach in front of the large eyes. Also, there is a hole in the top of the head that is designed to hold a carved ivory tusk. The ivory tusk is said to be a symbol of the link between the oba and the world of the spirits.

High collars of coral beads and lattice-work caps, adorned with rosettes and agate beads, were reserved for the oba, the Queen Mother, and high officials. Royal coral beads were only possessed by the oba. They had great mystical significance for they were connected to the deity of water, Olokun. They were said to

have the power to make anything said in their presence come true.

Brass heads could only be owned by the oba and were placed on an altar. Obas had these altars erected in memory of their predecessors. Lesser chiefs could own altars and furnish them with heads made of wood, like the sculpture in *Figure 3*. On wooden heads, the coral necklaces are replicated by carved circular rings. Incised patterns on the head imitate the coral net cap of the brass heads. Wooden heads have large eyes similar to the eyes on brass heads crafted during the eighteenth and nineteenth centuries.

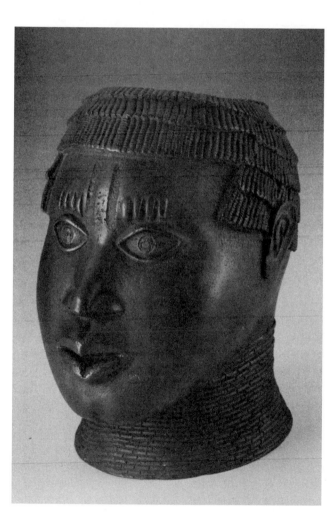

Figure 1 Created during the age of the warrior kings, this head might represent a trophy head because of the four scarification marks and the hairstyle. Edo peoples, Benin Kingdom, Nigeria, *Head*, late 15th–16th centuries. Copper alloy and iron, H: 8 3/4", (22.2 cm). Smithsonian Institution, Washington, D.C. Purchased with funds provided by the Smithsonian Collections Acquisition Program. Photograph by Franko Khoury, National Museum of African Art.

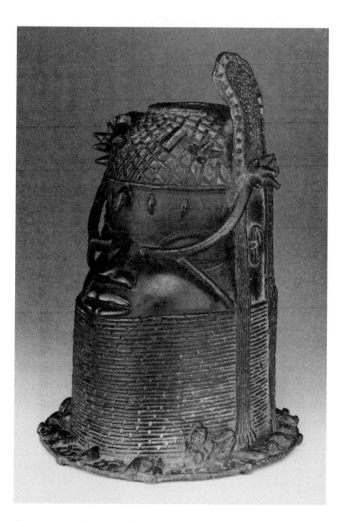

Figure 2 The flange and the wing seen on this head indicate that it was created during the reign of Oba Osemwede because he introduced royal headgear with standing "wings" on the sides. Edo People, Benin Kingdom, Nigeria, *Head of an Oba*, 18th century. Copper alloy, H: 15", (38.1 cm). Smithsonian Institution, Washington, D.C. Gift of Joseph H. Hirshhorn. Photograph by Franko Khoury, National Museum of African Art.

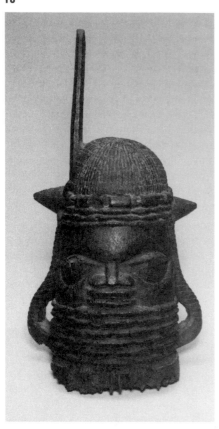

Figure 3 During the seventeenth to nineteenth centuries, chiefs requested the right to display wooden human heads on their own altars as a symbol of sacrifice. Edo people, Benin City, Nigeria. *Commemorative head of a chief.* Wood, H: 15 7/8", (40.3 cm). Gift of an anonymous donor in memory of James F. Young. Photograph by Franko Khoury, National Museum of African Art.

Metal workers also had altars with a row of heads, but their heads were of terracotta, a clay material. In the fourteenth century, during the reign of the sixth Oba of the Oguola dynasty, a brass caster named Igueghae, from Ife, was sent to teach the Benin artisans how to cast. Iguaghae apparently brought with him terracotta heads to use as models for the brass casters. He is commemorated as a divine ancestor. Before beginning a cast, artists will say special prayers and make sacrifices to Iguaghae and other deities.

World Art Connections

- Did you notice that the features on the Benin brass heads are similar and that the heads display idealized features? Why might a tradition of using generic or idealized features be important in making commemorative portraits? When an idealized standard is used, deformities or flaws aren't present. Benin is not the only world culture to have produced idealized commemorative portraits. In European cultures, commemorative state portraits were usually in the form of busts or paintings. In many instances, like those of Benin, the purpose was to glorify political ideals and not necessarily individuals.

- Locate reproductions of Piero della Francesca's frescoes. Piero della Francesca, was a sixteenth-century Italian artist, and a key figure of the Italian Renaissance. In his paintings, which commemorate an important event, the figures are notable patrons or religious figures. His work has been described as unemotional, and the figures in his paintings are idealized. What similarities do his figures have with the idealized traits of Benin brass heads?

- Piero della Francesca's idealized style has been compared to the art of Classical Greece. In the Western world, metal casting in bronze and brass was practiced by the Greeks who learned this craft from the Egyptians in the sixth century BC. Greeks produced life-sized cast figures, which were sometimes created in pieces first and then assembled, by making hollow castings using the lost-wax method. Many of these bronzes were copied in marble by the Romans. Locate photos of Greek portrait sculptures and compare them with the Benin heads.

Classroom Connections

- Look at one of the images of the Benin heads. Since these portraits are not exact likenesses of individuals but are generic representations, their individuality is represented in another way. Idealized and emblematic portraits do not depend on the accurate depiction of human form and facial features. Instead, the Benin artists used elements within the composition to stress a person's social position, occupation, achievements, or intellect. These elements are called **attributes.** What do the attributes tell us about the person being represented? Do these images represent ideals of beauty? What would those ideals be? Who would have determined those ideals? Identify attributes of the Benin head in *Figure 1* that might be symbolic. Write down what you think could be the significance of each attribute.

 Do you have any personal attributes? Can you use these attributes to create an emblematic self-portrait? Make a list of your personal attributes and another list of qualities that you would like to have. Create a self-portrait using collage as the technique. Depict yourself in an idealized form based on your ideal qualities. Will your classmates recognize you in the portrait? What features in the portrait reveals information about you?

The Benin Kingdom was located
in a high tropical forest
on the sandy plains of Western Nigeria.
It was founded by the Edo or Bini people
and its capital was Benin city.

Study Sheet

1 Why did artists create the Benin heads?

2 What materials and methods did they use?

3 What is the significance of coral beads and how are they represented?

4 Write a comparison of the formal qualities of the brass heads in *Figure 1* and in *Figure 2*, thinking about the following aesthetic concerns: simplicity, intricacy, idealization, expressiveness, and naturalism.

Resources

Museums
Baltimore Museum of Art, Baltimore, Maryland

Chicago Museum of Art, Chicago, Illinois

Cleveland Museum of Art, Cleveland, Ohio

Menil Collection, Houston, Texas

Metropolitan Museum of Art, New York, New York

Museum of Art, Carnegie Institute, Philadelphia, Pennsylvania

The Museum of Fine Art, Houston, Texas

The National Museum of African Art, Smithsonian Institution, Washington D.C.

Peabody Museum of Art, Harvard University, Cambridge, Massachusetts

Seattle Art Museum, Seattle, Washington

University of Indiana, Bloomington, Indiana

The University Museum, University of Pennsylvania, Philadelphia, Pennsylvania

Books
Ben-Amos, Paula. *The Art of Benin.* London: Thames and Hudson, 1980.

Ben-Amos, P. & Rubin, A. *The Art of Power, The Power of Art: Studies in Benin Iconography.* Los Angeles: Museum of Cultural History University of California at Los Angeles, 1983.

Brain, R. "The Artist: His Inspiration and His Materials." In *Art and Society in Africa.* London: Longman, 1980.

Duchâteau, A. *Benin: Royal Art of Africa.* Houston: The Museum of Fine Arts, 1994.

Dark, P.J. *An Introduction to Benin Art and Technology.* Oxford: Clarendon Press, 1973.

Dark, P.J. "Benin Bronze Heads: Styles and Chronology." In McCall, D. F. & Bay, E. G., eds. *African Images: Essays in African Iconology.* New York: Africana Publishing Co, 1975.

Preston, G. N. Sets, *Series and Ensembles.* Center for African Art, New York: Harry N. Abrams, Inc., 1985.

Articles
Belfour, H. "Modern Brass-casting in West Africa," *Journal of the Royal Anthropological Institute* (London), 40: 525–529, 1910.

2 Signs of Power

Chokwe Scepter

Crafting a Scepter

THE Chokwe people for the most part live in Angola. Small groups may also be found in Zambia and Zaire. The Chokwe were noted for their skills in hunting elephants. It was this skill and the surge in the ivory trade that allowed the Chokwe to expand their territory and power.

Chokwe staffs, or scepters, and other insignia of rank are carved by renowned artists who work mainly for Chokwe rulers and neighboring courts. Traditionally, artists made a scepter by cutting a piece of hardwood and using the length of an open hand to measure dimensions. The general form of the scepter head was carved first, then the rest of the body. Details such as facial features were drawn with charcoal and then cut out

with a sharp knife. Often the sculptors used other scepters as models. They replicated a model's proportions by measuring it with a blade of grass. The surface of the sculpture was smoothed with leaves that had a rough surface. The statue was then dyed a dark color by using vegetable juices.

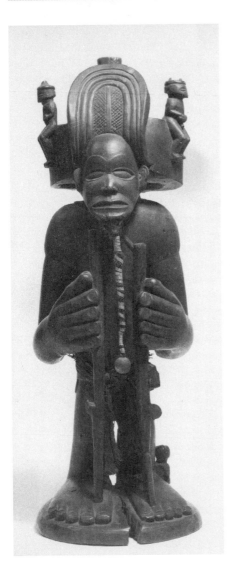

The two figures on the headdress of this statue represent protective spirits who inform the hunter of the presence of game. Chibinda Ilunga. Chokwe peoples, Zaire and Angola, 19th century. Wood 15 1/4", (38.7 cm). Staatliche Museen Preussischer Kulturbesitz, Museum für Völkerkunde, Berlin. Photograph by Eliot Elisofon, 1969. Courtesy of the Eliot Elisofon Photographic Archives, National Museum of African Art.

Chokwe Ruler's Scepter

Much of Chokwe art was created for prestige purposes. Hatchets, swords, masks, pendants, bracelets, chairs, stools, pipes, weapons, and scepters were and are still made for social display.

Scepters, which were one of many of the Chokwe chiefs' insignia, are said to represent high status, dignity, and masculinity. There were different kinds of scepters—those for dance, for commanding, and for traveling. The chiefs generally wore their scepters inserted in their belts or carried them to announce their rank in society when they traveled. They also used them to direct the work in the fields. Scepters and other paraphernalia were often passed down to the succeeding ruler.

Scepters consisted of a shaft, a mid-section called a plate, and a sculpted head or full body with an elaborate headdress as shown here. The plate was usually decorated with linear geometric patterns on both the front and the back. The patterns are carved in relief, or are raised. How would you describe the pattern on the plate in this example? It has a wavy, undulating pattern. This pattern symbolizes the viper, which is an important motif for the Chokwe.

The face on the scepter depicts idealized facial characteristics, such as a high forehead, almond-shaped eyes, a somewhat flattened nose, sinuous lips, and a rounded chin. The headdress identifies the individual represented on the scepter as a chief. This headdress, called *cipenya mutwe*, was worn on ceremonial occasions. It fans out at the top and has two winglike structures that point toward the back. The wings are said to represent the black stork, a bird that is connected to funerals in Chokwe mythology.

The scepter headdress corresponds to either of two types of actual ceremonial headdresses

worn by Chokwe chiefs and sub-chiefs. The first, *mutwe wa kyanda*, is constructed out of twigs. The twigs are tied together with fiber to create an armature, which is like a scaffold. This armature is covered with red, blue, and white cloth. Two strips of red cloth, long enough to touch the chest, hang from the side of the headdress. Sometimes these headdresses are embellished with colored beads, nails, or metal string.

The second headdress, called a *cipenya*, is a metal crown in the form of a headband. The crown is made out of strips of copper, decorated with brass ornaments or with embossed motifs. The large metal band forms two convex shapes that arch towards the back of the head. You can see how these convex forms are represented by the wings on the scepter headdress.

The headdress on the scepter is a combination. It has the strip across the forehead and the wings which are characteristic of the *cipenya* and the fanning out aspect of the *mutwe wa kyanda. Chipenya* means headband and designates a metal ornament. *Mutwe* means head. *Mutwe wa kyanda* means chief's hat. The *cipenya* and the *mutwe wa kyanda* can be seen on figures carved on other objects as well, such as chairs, tobacco mortars, and larger statues known as hunter statues.

The images of a figure wearing the *cipenya mutwe* sometimes represents a legendary Chokwe chief called Chibinda Ilunga. (See the portrait carving.) Chibinda Ilunga is credited with developing a more efficient hunting system, but also with instituting an oppressive political system. One version of his legend says that around 1600,

Scepters served many purposes. When not in use they were stored in special containers. Chokwe of Angola, Moxico region, *Chokwe Scepter*. Wood, 23 5/8", (60 cm). University of Pennsylvania.

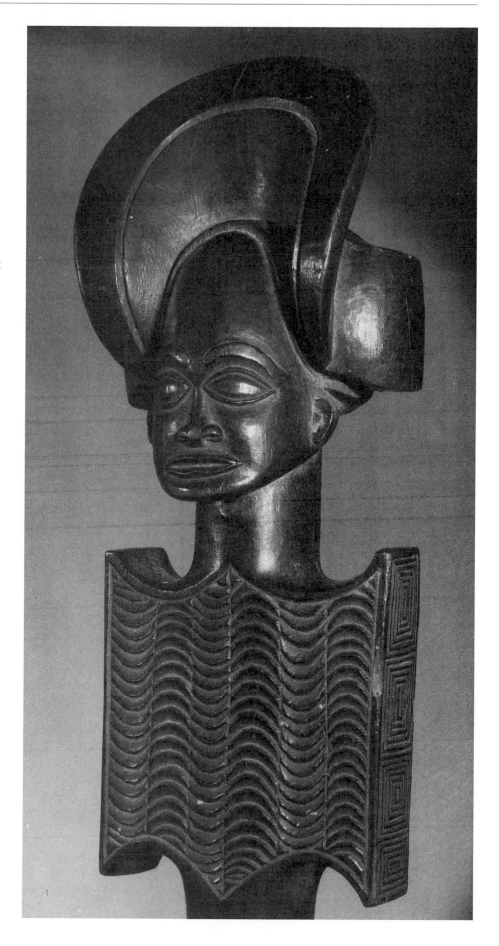

Chibinda Ilunga, who was a Luba hunter, wandered into Luunda territory, thirsty after a hunting session. He drank some palm wine that did not belong to him. Being honest, he left as payment some of the game he had killed.

The owner of the land found the game and took it to the Queen Lueji, who was very pleased and wanted to meet this hunter. Lueji sent attendants out to find him. Chibinda offered Lueji many gifts from his hunt. Lueji was so impressed she invited him to stay. After a time Lueji fell in love with the hunter and wanted to marry him. They were married and founded the Luba-Luunda kingdom.

However, apparently Chibinda was not so honest after all. He stole a bracelet, which was an emblem of authority, from Lueji and became the chief. Then he reorganized the government and changed the way power was passed down from **matrilineal** to **patrilineal**. This angered Lueji's brothers because they knew that their children had lost the opportunity to rule. They fled the kingdom and established new settlements in Angola.

World Art Connections

● Works of art from nearly every culture can be connected to myths and ancient stories. How many mythologies of the world can you think of? Norse, Native American, and African are major categories that might come to mind. Yet within these categories there are numerous separate mythologies. Look for examples of art that depicts myths or stories from Oceania, China, Mexico, or India. In many cases, you may notice that the whole myth is not shown, but perhaps one individual, whose presence may recall the entire myth when the object or image is looked at.

Stories from Greek mythology are familiar to people who have grown up in Western society. These myths have been referred to in art, literature, and music throughout European history. Which Greek myths are you familiar with? Just as the head of a Chokwe staff depicts the mythological being Chibinda Ilunga, Greek vase paintings and architectural sculptures depicted scenes from ancient Greek mythology. Renaissance artists of the fifteenth century also represented myths in their paintings. Locate paintings by the Italian painters Sandro Botticelli and Titian, for example, in which they depicted the goddess Venus.

Myths help explain the images we find in art, and the art helps explain myths. We know, for example, that the head of the Chokwe staff depicts Chibinda Ilunga because of the headdress worn, or that a particular painting on a Greek vase depicts Hercules because he is wearing a lion's skin. The images from myth may tell of a being's special quality or of some important event. For example, Chibinda was said to possess powerful charms that would enable him to attract game when hunting. Do you think the large hands and feet are related to his hunting skills?

Many myths centered on heroes or heroines whose adventures or exploits help explain aspects of the real world. Some mythological figures changed the world or the community by their cunning, wit, or strength. Chibinda Ilunga introduced a more efficient way of hunting and a different governing system after tricking Lueji out of the bracelet. Hercules, because of his superhuman strength, was able to support the sky. Find a description of the Greek goddess Diana and compare it to the myth of Chibinda Ilunga.

● Find a reproduction of Harriet Powers' *Pictorial Quilt*. Powers was an African American who combined biblical stories with a visual style influenced by African motifs. Select one of the quilt panels and compare its silhouette style with the Chokwe scepter. Notice how each artist decided to keep details at a minimum. How do you think reducing the number and kind of details gives simplified forms a visual power?

When Chokwe scepters were first encountered by Europeans they were thought to represent a god of ancient Egypt ,because of the naturalistic rendering of the face and the *uraeus* decoration found on the front of some of the carved headdresses. The *uraeus* is the figure of the cobra, which was found on the headdresses of ancient Egyptian rulers.

The headdress found on the
Chokwe scepter is also represented
in a mask called *Cikungu.*
This mask, like the headdress
on the scepter, has a fan-shaped
front with spread wings.
It personifies the dynastic ancestors.

Resources

Museums

The Dallas Museum of Art, Dallas, Texas

The University Museum, University of Pennsylvania, Philadelphia, Pennsylvania

University of Iowa, Iowa City, Iowa

Books

Kaehr, R. & Rodrigues de Areia, M. *Les Signes du Pouvoir (Signs of Power).* Neuchatel: Musée d'Ethnographie, 1992.

Bastin, M.L. *Statuettes Tshokwe (Chokwe Statues),* Arnouville: Arts d'Afrique Noire, 1978.

Bastin, M.L. *Art Decoratif Tschokwe (The Decorative Art of the Chokwe).* Lisboa: Companhia de Diamantes de Angola, 1961.

Classroom Connections

• Mythological heroes and heroines have particular characteristics that are generally superhuman. What do you think might have been some of Chibinda Ilunga's superhuman qualities? Identify characteristics of modern day heroes or heroines from real life, or from art, books, movies or television. Create your own heroes and heroines, giving them special attributes. Select one and make a clay sculpture, showing the superhuman qualities in a visual way, perhaps using headgear, scepters, special decorative motifs, or exaggerated physical features, such as a large forehead. Give your figure a name and write a brief story that reveals the hero of heroine's special nature.

• Scepters were originally made as functional objects, yet they are also works of art. How can you defend the scepter as a work of art? Work with a partner to list the criteria for an object to qualify as a work of art in Western art historical terms. How many of these criteria fit the Chokwe scepter as it is used in Angola? Do you think those criteria must necessarily apply for an object to be art? Why or why not?

Study Sheet

1 Name different ways that scepters were used by Chokwe chiefs.

2 In this example, what does the scepter's headdress represent?

3 Why would the Europeans have thought that the Chokwe scepters found in Angola, a country in southwest Africa, would have come from Egypt, a country in northeast Africa?

Yoruba Crown

Embroidering a Crown

BEADED crowns in the Yoruba culture of Nigeria are made by professional male artists for obas, the Yoruba rulers. The beaded crown, called an ade, was traditionally crafted with complex cultural symbols that described the nature of the divine king, who could trace his lineage back to one of the sixteen sons of the creator god, Oduduwa. Oduduwa is considered the maker of land and is the legendary founder of the Yoruba people. Yoruba legend says he initiated the wearing of the ade, for he placed a crown on the head of each of his sixteen sons.

The artist's first step in making the crown is to prepare a foundation for the beaded embroidery. He uses starch to glue layers of white cotton or muslin cloth over a frame made of wicker or cardboard. Areas in relief are created by shaping and building up pieces of cloth dipped in starch. Once the foundation is made, it is dried in the sun.

Artists who made crowns centuries ago embroidered backgrounds that formed patterns designated by the Oba. Generally, an embroidery design is planned and sketched onto the foundation before the beading begins, or the artist may choose to work from memory. The artist strings beads into strands of a single color and stitches them to the fabric to form the geometric patterns and other designs. When the embroidery and relief elements are complete, the inside of a crown is lined with cloth and a veil of beads is added.

A crown might take as long as six months to make. Artists work in their own homes or in a room in the chief's palace. The most important family of crown-makers today lives in Efon Alaiye. Efon Alaiye is one of the leading crown making industrial centers. It is located northwest of Ise in Nigeria.

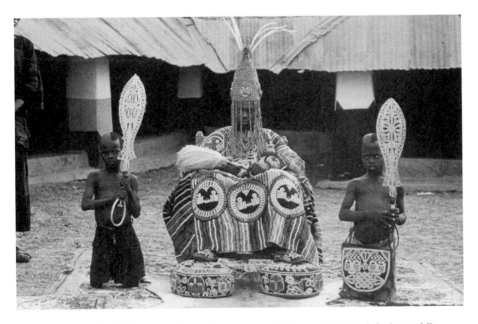

Yoruba kings, called Obas, wear beaded crowns on state occasions and during public functions. Yoruba peoples, Nigeria, *Oba Adenuwagun Adesida II the Deji of Akure, on throne in courtyard of Akure palace.* Photo by Eliot Elisofon, 1959. Eliot Elisofon Photographic Archives, National Museum of African Art.

Beaded Ade

Traditional beaded Yoruba crowns may be of three types: cone-shaped, a cone with a stem, or an "elliptical helmet" form. The crown illustrated here is a cone with a stem. Crowns include a beaded veil, faces in relief or partial relief, and beaded birds (okin) attached to the crown's circumference. An embroidered bird or groups of birds is often present. The veil, the relief faces, the birds, and the interlaced patterns are important symbols on the crown.

The earliest crowns, made in the eighteenth century, were of a fairly simple design. They were cap-shaped with a stem on top and included cowrie shells. The crowns were also decorated with African-made red jasper beads or coral beads imported from Portugal. Look at the three sections of the cone-shaped part of the crown. The top section has zigzag patterns of contrasting colors

and figures of birds in the round. The middle section has diamond-shaped patterns in contrasting colors with two colorfully beaded birds on each side of the crown. The birds in these first two sections appear to be pecking. In the front of the third section, notice the face and the interlaced patterns.

Multicolored veils were attached to the crowns. The veils were decorated with rows of single strands of colored beads, beaded sashes decorated with birds, and multicolored netting. The veil's purpose was to hide the face of the king and shield the subjects from his stare, which was thought to be harmful. Looking on his face carried the threat of death. When the king's face was hidden by a beaded fringe, he was said to no longer be a man, but a deity. Rulers also wore beaded footwear and used a beaded footstool so that their feet would not touch the ground. Find the footstool in the photograph of Oba Adenuwagun Adesida II.

There is no consensus as to the meaning of the faces depicted in relief at the front of the crown. They may just be decorations. However, they could represent faces of ancestors, because of the presence of facial markings. They could also represent the skulls of slain enemies or women with magical powers, indicating victory over such forces. Or, perhaps, they might represent the faces of Yoruba gods, such as Oduduwa, the first ancestor of the Yoruba people, Obalufon, the inventor of beads, or Olokun, the god of the sea, who is the owner of beads. Legend has it that the very first crown was brought by Olokun. Whoever the faces on the crown represent, they suggest the

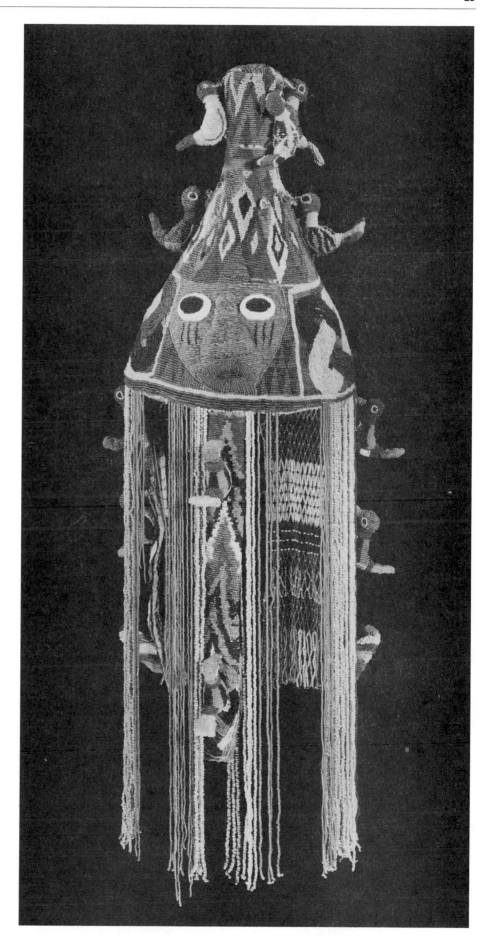

The birds on the crown are possibly egrets, heron-like wading birds with white plumes. The egret among the Yoruba is a bird of decorum and a sign of orderliness. Yoruba, Ijebu region, Nigeria, *Crown (ade)*. Glass beads, fiber, iron, cotton. Gift of Milton F. and Frieda Rosenthal. Photograph by Franko Khoury, National Museum of African Art.

king's omnipresence, his awareness of all that goes on around him on all sides. His eyes were said to be all-seeing and could behold the entire town so that nothing could remain secret from him. When the crown is not in use, it is stored in a palace shrine. When the Oba travels the crown may be publicly displayed on the Oba's throne to protect the town in his absence.

The cone of the crown was hollow and was said to contain very potent medicine. These medicines were said to be able to kill anyone, other than the rightful ruler, who attempted to take over power by putting on the royal crown. Even the king himself would be blinded if he ever ventured to look into a crown, rather than simply wearing it.

Traditionally, the birds that are attached to crowns might have symbolized the power of elderly women. Elderly women were thought to have magical powers that could be beneficial or destructive. The birds represent the presence of the potential destructive forces. It is considered to be something of a servant to the elderly women. The presence of the birds on the crown, however, was said to allow the king to assume and neutralize these powers.

In some areas, the number of birds on the crown may have indicated the rank of the ruler. Four birds might indicate a minor ruler, whereas a crown with sixteen birds might mean that it belonged to a great paramount chief. The number of birds may have also reflected the distribution of power by representing the number of wards in a ruler's town.

The interlaced pattern is associated with royalty or at least leadership. Some in the Yoruba culture interpret this symbol as an abstraction of two intertwining snakes biting each other's tail. The interlaced pattern could also represent the perfect image of royalty, each individual king being only a part of the unending and eternal line of royal ancestors.

The crown is of such a special nature that the artists must perform special rites before making it. For example, because the artist is going to use an iron needle, the crown maker must first sacrifice a pigeon, fish, snail or tortoise to Ogun, the deity of iron. The snail is for peace, particularly peace of mind to carry out the work, and the tortoise for wisdom and shrewdness to let the work succeed. Then the crownmaker must make a sacrifice to Olokun, in remembrance of the fact that he gave the very first crown.

The Yoruba are primarily urban dwellers and are well known as traders. They currently comprise nearly a quarter of Nigeria's population.

World Art Connections

● In creating the beaded crown the Yoruba artists used contrasting bright colors. Their choice of colors, and the designs they created based on color, were deliberate. What words would you used to describe the crowns' colorful patterns and their effects? In the case of the royal garments for obas, why might bold colors and designs be important?

Some Western artists of the 1960s and later have used the optical effects of color as the main focus of their work. Locate paintings by Bridget Riley, Victor Vasarely, and Joseph Albers. What happens when certain colors are placed next to each other in geometric or repeated patterns? In general, how would you describe their paintings. Does your list of words duplicate any you thought of for the crowns?

The use of intense and saturated colors was a hallmark of the Fauve artists, a group who painted with a deliberately shocking use of color in France early in the twentieth century.

Classroom Connections

● Many of the surface patterns and motifs that appear on Yoruba beaded crowns are created out of strands of beads, which are cut in lengths appropriate for filling in particular patterns. Look closely at the crown and identify as many patterns and motifs as possible. Notice the directions in which the beads are sewn. On a piece of paper, recreate two motifs by drawing the lines created by the beads, so that you can see the crown in terms of linear patterns.

Color was not intended to be realistic, but more to have emotional impact for these artists. Find out why they were called "the Fauves." Locate early paintings by Henri Matisse, such as *The Red Studio*. Presumably, Matisse's studio was not actually red floor to ceiling, but in the painting, Matisse has made everything red except canvases and sculptures and a few objects in the studio. What do you think he meant to express about his work space in this painting?

Yoruba artists used colors to intensify relief elements, to make specific areas more impressive, and to emphasize forms. For example, the crown shown has a bright orange face with a blue mouth. The face is placed on a green and red background. Scarification stands out by making the marks blue against orange, and the eyes are accentuated by making them white and black. We cannot assume that the Yoruba artists' use of colors in this way was specifically for emotional impact. Why not?

Resources

Museums
The National Museum of African Art, Smithsonian Institution, Washington, D.C.

Fowler Museum of Art, University of California at Los Angeles, Los Angeles, California

Brooklyn Museum of Art, Brooklyn, New York

Books
Beier, U. *Yoruba Beaded Crowns: Sacred Regalia of the Olokuku of Okuku.* London: Ethnographica, 1982.

Carey, M. *Beads and Beadwork of West and Central Africa.* Princes Risborough: Shire, 1986.

National Museum of African Art. *Beaded Splendor.* Washington D.C.: Smithsonian Institution, 1994.

Thompson, R. F. *Black Gods and Kings.* Los Angeles: University of California, 1971.

Thompson, R. F., "The Sign of the Divine King: Yoruba Bead-embroidered Crowns with Veil and Bird Decorations." In Fraser, D., & Cole, H. M. eds. *African Art and Leadership.* Madison: The University of Wisconsin Press, 1972.

Articles
Brinkworth, I, "The Crown Makers of Efon Alaiye," *West African Review*, 29: 729–732, 1958.

Mellor, W.F., "Bead Embroiderers of Remo," *Nigeria* (Lagos), 14: 154–155, 1938.

Thompson, R. F., "The Sign of the Divine King: An Essay on Yoruba Bead-embroidered Crowns with Veil and Bird Decorations," *African Arts/Arts d'Afrique*, 3(3): 1–17, 74–80, 1970.

• In art history, works of art are studied as research documents that reveal cultural and contextual information. Art can provide visual clues that can be used as a means for discovering information about the culture from which the artwork comes. For example, the presence of the veil on the Yoruba beaded crown is a clue. What do veils usually indicate? Why are they used? What does the Yoruba veil tell us about the kingship? Look at the beaded crown and list other visual clues that may reveal information about the Yoruba attitude toward kingship. Work in small groups to

discuss the relationship between the visual clues you observed and the culture of the Yoruba king, the Oba. When you are finished, write a paragraph or two describing the characteristics and nature of the Oba without making reference to the actual crown.

Study Sheet

1 Why did Yoruba artists make sacrifices to Ogun and Olokun before starting a beaded crown?

2 Who is the Oba and when and why does he wear a beaded crown?

3 What elements traditionally appear on a Yoruba crown?

4 What do birds signify on a crown?

5 What is the relationship between Oduduwa and beaded crowns?

Ndebele Beaded Apron

Women's Art

MANY African people use beads as a part of their personal clothing and adornment. For some people, such as the Ndebele of South Africa, beadwork is a major means of artistic expression. The term Ndebele refers to a relatively broad range of ethnic groups dispersed across Zimbabwe and the Transvaal province of South Africa.

The Ndebele people have been doing beadwork for centuries, but the art form seems to have developed rapidly around the latter part of the nineteenth century.

Beadwork serves several societal functions: it identifies the status of the women in society; it adorns individuals and objects, especially ceremonial dress; and it serves as a source of income.

In the Ndebele culture, women communicate ethnic heritage and knowledge, and they do so through the decorative arts, primarily beadwork and house **murals.** The methods used to create the intricacies of beadwork and the painted murals for interior and exterior walls of houses are passed from mother to daughter and sister to sister. Remarkably, bead patterns are worked out directly on the garment or ornament, without preliminary drawings.

Ndebele women originally sewed beads onto leather. Later they combined leather with canvas, with the leather on the outside and the canvas on the inside, acting as a lining. In early times, beads were so small that even a very thin commercial needle could not fit through the opening in them. They were sewn together with **sinew,** because sinew was stiff and thin enough to make its own point and still fit through the hole in the beads. Ndebele women today prefer to use a larger variety of beads that can be sewn on with a needle and thread.

Ndebele Beadwork

Before the introduction of European glass beads, African peoples used beads made from indigenous materials, such as ivory, animal teeth, sea shells, ostrich egg shells, bones, seeds, and clay. Glass beads were introduced to southern Africa in the sixteenth century by the Portuguese, who were interested in trading beads for gold and ivory. When other Europeans, such as the Dutch and the British, saw the value of beads they, too, started trading enormous quantities of glass beads with the people of southern Africa.

Have you ever examined a beaded object or garment up close? You may have noticed the surface texture created by tightly strung beads. Think about how the ways in which light playing off the surface of the beads would increase their aesthetic appeal. Why do you think the Ndebele people would have traded for glass beads? What was different about

glass beads from the beading materials traditionally used by the Ndebele, and other African peoples as well? Although we cannot know all the reasons why, we can speculate that the intense colors of glass beads were unusual compared with the indigenous materials, and were therefore valued. The beads also were valued because they were foreign and exotic. Beads are aesthetically intriguing at close range and from a distance. Imagine the effect of hundreds of beads of the same color woven together. They will possess an intensity of color unlike any other media.

Among the Ndebele, beaded ceremonial dress and beaded garments belong exclusively to the realm of women. Made and worn by women, the garments provide information to the members of the group about the social status of Ndebele women and the transitional periods in their lives. Varieties of beaded attire indicate whether a female is a child or an adult, married or unmar-

ried, a recent bride, or the mother of a young male being initiated into adulthood.

At puberty, the young Ndebele girl wears a rectangular beaded *pepetu* or maiden's apron. The apron is made of leather and is covered with cloth and then beaded. The young girl wearing the *pepetu* indicates to the community that she is ready for marriage.

The bridal apron, or *jocolo*, such as the one shown here, is given to a woman by the relatives of her husband. The apron consists of a rectangular base from which five panels hang. The ends of the panels are scalloped. The panels refer to a woman's

Simple designs on beaded garments were for everyday use while more elaborate patterns, such as this one, were for ceremonial use. Ndebele peoples, South Africa, *Bridal Apron (Itshogolo).* Glass beads, fiber, canvas, 25" x 19 1/2", (63.5 x 49.5 cm). Gift of Mr. & Mrs. Chaim Gross, Photograph by Franko Khoury, National Museum of African Art.

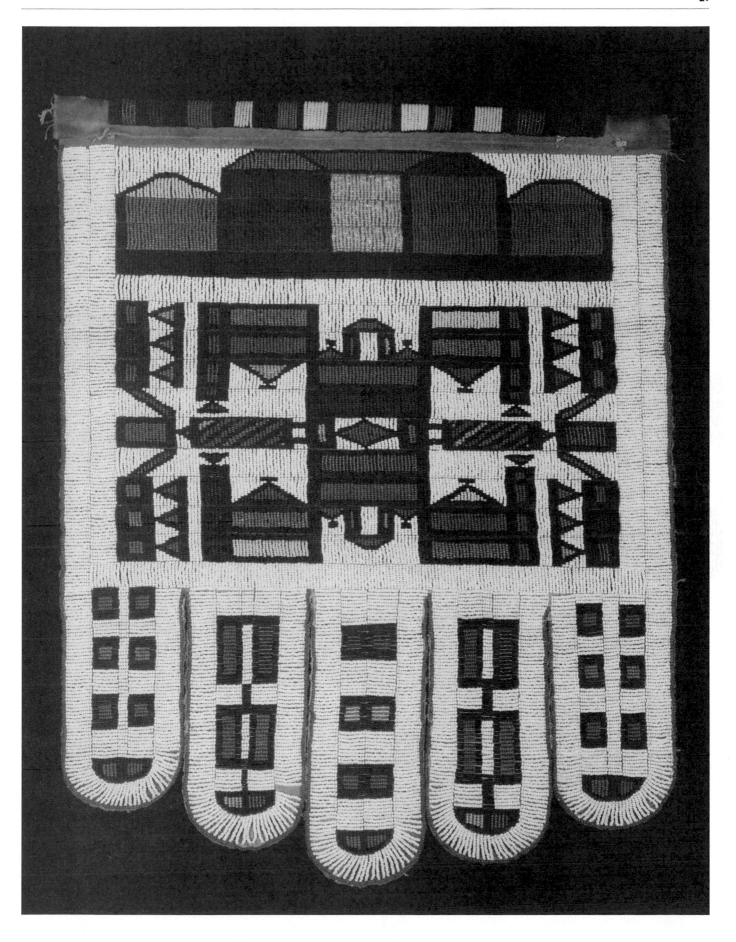

ability to bear children. The apron is given in the spirit of joy and expectation. The apron is presented to the bride without beads. A combination of netted and lacy beadwork is applied by the bride after the marriage. Notice how the apron's patterns are symmetrical. These designs are similar to those found in Ndebele house paintings and are evocative of the shapes of Ndebele houses themselves. For the apron, the artist combined analogous colors—blue, green, purple, and pink—using orange as a complement.

In addition to the beaded garments, young women wear hoops around their neck, arms, and legs. These hoops, made by coiling bundles of dried grass or corn leaves and covering them with cloth, have strands of colored beads tightly sewn around them. The beaded hoops are often made directly on the body and are not removable. Only when the woman's husband dies are hoops cut off. Women about to be married often have a healer fit layers of brass rings, by soldering them, under each beaded hoop.

Ndebele women use predominately geometric patterns in their beadwork and murals, using the same motifs, shapes, and symbols, and a sense of balance. Today, many of the traditional geometric forms and patterns have been replaced by motifs recognizable to the Western world, such as airplanes, telegraph poles, and letters of the Roman alphabet.

Each cultural group in South Africa has a distinctive beadwork style, which consists of combinations of colors and patterns that characterize their region. The oldest and more traditional examples of Ndebele beadwork patterns are created in translucent reds, blues, greens, and orange against a white background. In the early 1970s, color preference suddenly shifted from the use of translucent beads toward combinations of opaque beads in blues, greens, purples, and black.

Girls learned the art of beadwork from their mothers or their sisters at the time of initiation, when a girl reaching puberty goes through rituals and ceremonies to prepare her for womanhood. Most of the garments created are worn during initiation rituals and celebrations, and they are worn in honor of the ancestors. Ndebele women's personal adornment is practiced in its highest form during these occasions.

For ceremonial and celebratory occasions, Ndebele women create and wear **Gala blankets** that have intricately beaded trimming *(ngurara)* and long, beaded strips (*milingakobe* meaning "long tears"), which are attached to their headbands. They wear lavishly beaded skirts and beaded copper rings worn on their legs, arms, and neck. The rings are studded with glittering tacks. These garments may be worn during coming-of-age ceremonies, weddings, visits to relatives, and family gatherings. A beaded garment adorns the body and distinguishes the individual from women of other tribes. Generally the beaded garments are not a part of everyday wear because they are too expensive. Even through glass beads are more readily available now than in earlier times, they have become extremely costly, about twenty cents for eight beads. When you consider that some beaded garments require thousands of beads, you can see how creating a beadwork garment can become a costly affair.

Classroom Connections

• The Ndebele women beaded aprons, bridal trains, blankets, and headbands, using geometric and symmetrical patterns. The patterns are said to represent objects from everyday life. The shape of a house lends itself well to being transformed into a geometric pattern, but what about trees or animals? How can an artist represent an organic shape geometrically? Try it yourself. Select three organic objects and sketch a two-dimensional geometric representation for each. Then create a mosaic of one of your designs, using beads or colored seeds. Use black seeds or beads for outlines, as in the Ndebele apron and then fill in areas with different colors.

The capital of the Transvaal is Pretoria.
Its largest city is Johannesburg.
The Transvaal is rich in mineral resources.
Best known for its gold and diamond mines,
it also has plentiful uranium,
platinum, iron ore and coal.

World Art Connections

● The geometric patterns in the Ndebele beadwork and mural art can be paralleled with aspects of the European and American color field artists. Color field paintings were generally large works that examined the effects of color on canvas. Some included geometric forms rendered with flat color and precise outlines, and these are known as hard-edge paintings. Like the hard-edge paintings, the designs on the aprons are precise with simplified, repeated forms that create visual rhythms.

Locate works from the late 1960s and early 1970s by artists such as Kenneth Noland and Frank Stella, who were working in a hard-edge style at that time. Noland created symmetrical chevrons of bright colors. Frank Stella's work also shows a strong sense of symmetry created by the rhythmic repetition of shapes. Stella's colors were varied, utilizing narrow white lines of unpainted canvas between areas of color. The white lines create a border around the colored areas in much the same way as black beads were used in the Ndebele aprons to outline the colored areas.

What other comparisons can you made between color field painting and Ndebele designs? Notice how color is emphasized in both instances.

If possible, locate other examples of Ndebele beadwork or house murals. Compare your geometric designs with those of the Ndebele women. What similarities do you notice? Write a short analysis of your geometric design in which you consider the following: media, technique, composition, color scheme, and types of patterns used. Note whether your work is vertically and horizontally symmetrical.

Study Sheet

I Who are the Ndebele and where do they live?

2 What materials for beadwork did Ndebele women use before they traded for Dutch and other European glass beads?

3 Europeans traded beads to Africans in South Africa in exchange for what?

4 Who wore the Ndebele beaded aprons and what did the garments signify?

5 What else did the Ndebele adorn with beads?

Resources

Museum

The National Museum of African Art, Smithsonian Institution, Washington D.C.

Books

National Museum of African Art. *Beaded Splendor.* Washington, D.C.: Smithsonian Institution, 1994.

Carey, M. *Beads and Beadwork of East and South Africa.* Princes Risborough: Shire, 1986.

Courtney-Clarke, M. Ndebele: *The Art of an African Tribe.* New York: Rizzoli, 1986.

Levinsohn, R. *Art and Craft of Southern Africa: Treasures in Transition.* Craighall: Delta Books, 1984.

Articles

Priebatsch, S. & Knight, N, "Traditional Ndebele Beadwork." *African Arts* (Los Angeles), 11(2): 24–27, 1978.

Levinsohn, R., "Ndebele Beadwork," *Ornament,* 4(2): 61–63, 1979.

Levinsohn, R., "Beadwork as Cultural Icon," *American Craft* (New York), August/September: 224–31, 1985.

Hausa Robe of Honor

Cloth Embroidery

THE word *Hausa* refers to a group of people who observe the Moslem faith and live in the savanna region of the northern part of Nigeria. Hausa weaving dates from the fifteenth century, but Hausa embroidery was first reported by travelers and missionaries in the early years of the nineteenth century. Embroidery is the stitching of thread designs onto cloth. Among the Hausa, men design and produce embroidered patterns, particularly for the men's Robes of Honor, a special garment made for men of royalty or high status. Because of increasing demand for these robes, embroidery as an art form flourished through the end of the 1800s.

Embroidery is the most important part of the process of making Hausa robes. But it takes more than one person and a chain of operations to complete a robe. First, cloth is woven into bands, which are stitched together at the edges and then fashioned into garments. Before the embroidery begins, a specialist draws designs on the garment, using a red dye made from the leaf sheaths of a variety of guinea corn, and a pen made from guinea cornstalks. Then an embroiderer stitches the design, with colored threads, into the drawn lines.

Embroiderers hand-embroider or use a machine. Machine embroiderers tend to be more artistically "free" in their designs. They are less restricted by conventions. Hand-embroiderers follow traditional methods. Their needlework includes chain and buttonholed stitches, and couching and needle weaving. It usually takes months to complete the hand-embroidery for a robe. When finished, the robe is beaten with wooden mallets to compress the threads and create a slight surface gloss.

The male specialists who practice embroidery learned it as an apprentice to a master embroiderer or by self-training. Historically, embroidery masters were scholars of the Koran, the Moslem holy book. Koranic scholars often traveled from place to place setting up village schools or urban centers of learning.

Traditionally, the robe cloth came from locally cultivated and processed silk or cotton, and silk or gold thread was used for the embroidery. Women and slaves processed and spun cotton into thread and wove it into cloth, called **caliphate** cloth. Today, robes may be made from imported cotton thread from Europe, European factory-made cloth, or hand-woven fabric. However, the embroidery is still done locally.

Hausa robes of several varieties can be found in the marketplace today, but only those of the highest quality are purchased and worn by the elite. The value of a robe depends on the material used, the quality of the thread, the density of the weave, and the quality of the lining.

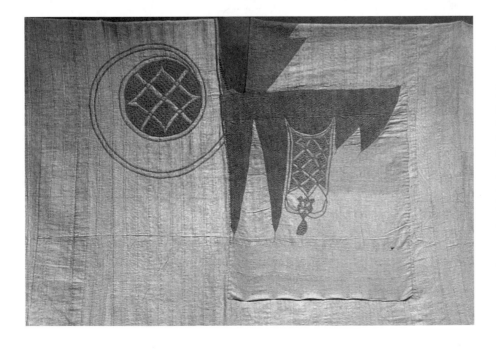

Hausa Robe of Honor

Dress is and has been a measure of status and authority among the Hausa and within the Islamic world since the eighth century. Two kinds of large robes, or prestige gowns, are worn by the Hausa male aristocracy of Kano **Emirate** in Northern Nigeria: the *riga* and the *girke,* a larger version of the *riga.*

This man's gown is showing the two knife patterns and is an example of the riga robe. *Man's Gown (Agbada).* Native woven cotton, 48" x 105", (121.9 x 266.7 cm). Fowler Museum, UCLA, Los Angeles.

These Robes of Honor are worn by the royal family, office holders, and other members of the nobility. Wearing the embroidered robes, Hausa men project a public image of wealth, social status, religious piety, and political authority.

The more prestigious of the embroidered designs are the Two Knives motif found on the riga and the Eight Knives motif on the girke. (Figures 1 and 2) Two Knives is the oldest and is characterized by paired elongated triangles that point downward from the top of the robe pocket on the left side of the robe front. The full pattern extends over the shoulder and ends in a spiral motif on the back. Two Knives may refer to Dhu 'l-Fakar, an Islamic Prophet who carried a sword with two points, which were said to have magic properties and put out the eyes of the enemy.

The Eight Knives motif was more prevalent during the nineteenth century. It has five elongated triangles projecting down from the top of the pocket, plus three smaller horizontal knives extending across the left shoulder from the neck opening. Eight Knives extends into two spirals, one on the back and one to the right of the pocket.

Robes of honor were typically the following colors and designs: black glazed, blue and white checks, red and white strips, glazed indigo, or white. Two Knives most often appeared on the glazed indigo robes; Eight Knives were sewn on the blue and white checked and red and white stripped robes. White robes were embroidered with both motifs.

Superiors gave robes as gifts to their subordinates, often as an offer of protection and to symbolize their relationship. Robes were most often worn on religious and political occasions. White was the color of choice for religious occasions, such as the end of the Moslem fasting period

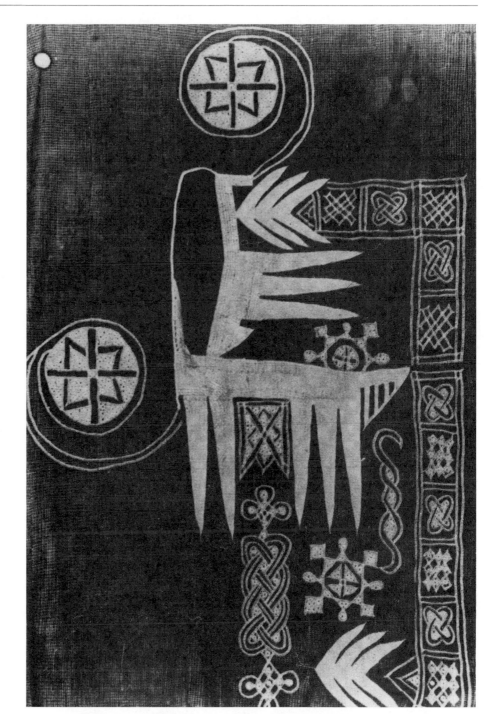

of Ramadan. Colored robes were worn for political events. Several of the embroidery patterns represent good fortune, victory in war, official insignia, and protection against evil.

Look at the embroidered details in the photographs and locate the spiral motif. Spirals appear on the right chest and back.

Man's Robe (Agbada). **This robe comes from northern Yorubaland. It is an example of the eight knife pattern which usually appears on the large girke robes.**

The symbol, called *tambari* or "king's drum" represents Hausa chieftancy and protection. When the spiral motif with a crossed circle is found on pendants, weapons, and on palace and mosque facades, it is said to have protective properties.

The eight-pointed star seen in Figure 2 is found on the left side of Robes of Honor, on Islamic banners used in war and on pilgrimages, in Koran illuminations, and on tomb covers. This symbol served as protection against the evil eye in some Islamic cultures. The evil eye is a look or stare which some believe is able to harm or bewitch the one stared at. In Islam this symbol would protect against bewitching.

World Art Connections

- Why do you think emblems and insignia have been used in world societies throughout history? What advantages are there in making a special rank or membership immediately recognizable? In European cultures, the power and pageantry of royalty have been portrayed through clothing, heraldry, emblems, and other regalia. Locate the portrait, *Napoleon in His Study* (1812), by the French neoclassicist Jacques-Louis David. Notice Napoleon's Legion of Honor medal and the Iron Cross of Italy. What other elements of the painting indicate Napoleon's self-proclaimed status as emperor?

Status and wealth may also be shown in the type of fabric from which a garment is made. In eighteenth-century Europe, brocade silk taffeta was the fabric of choice for a wealthy woman's gowns and, similar to the silk Hausa robes with silk embroidery, these gowns were objects of prestige. Artists commissioned by aristocratic patrons for portraiture often paid close attention to rendering the detail of clothing. Locate paintings from the late Baroque and Rococo periods in which the fabric of gowns shows an artists' technical skill.

In China during the Shang and Zhou dynasties (1600–221 BC), the protective properties of a garment were not located in decorative patterns or motifs, but in the actual material used to create the garment. Jade, commonly used for amulets or charms, was believed to hold spiritual qualities. Jade clothing found in tombs from this

The square divided into nine equal parts is found on the pocket near the knives patterns (see pocket of robe pictured on p. 2). Five of the squares (the corner and the center) are filled in with embroidery and the other squares are empty. In some compositions this motif appears as a crossed lozenge or interlocking form. It is called "house of bees" or "house of five." The number five is considered a charm against evil.

Classroom Connections

- What can clothing tell us about an individual? How do we express status and authority through clothing in our society? The Hausa Robes of Honor were said to reveal the wealth, social status, religious piety, and political authority of the individuals who wore them. How does clothing in the United States reveal information about the social status, economic position, religious affiliation, or political authority of individuals in our society? Discuss with classmates how such information is easily recognizable. To whom?

period probably was intended to protect the dead on the journey to the afterlife.

In Northern Europe, Albrecht Dürer's sixteenth-century engraving titled *Knight, Death and the Devil* depicts a knight in armor. Metal armor protected the wearer in battle. Like the wearer of a Hausa robe, the knight was said not to fear evil and ignored the threat of death because he was protected.

Resources

Museums
The National Museum of African Art, Smithsonian Institution, Washington D.C.

Fowler Museum, University or California at Los Angeles, Los Angeles, California.

Books:
Perani, J. "Northern Nigerian Prestige Textiles: Production, Trade, Patronage and Use." In Engelbrecht, B. & Gardi, Bernhard eds. *Man Does Not Go Naked: Textilien und Handwerk aus afrikanishen and anderen Ländern.* Basel: Wepf & Co. AG Verlag, 1989.

Articles
Heathcote, D, "Hausa Embroidered Dress," *African Arts* (Los Angeles), 5(2): 12–19, 82, 84, Back cover, 1972.

Kriger, C, "Robes of the Sokoto Caliphate," *African Arts* (Los Angeles), 21(3): 52–57, 78–79, 85–86, 1988.

Perani, J. & Wolff, N., "Embroidered Gown and Equestrian Ensembles of the Kano Aristocracy," *African Arts* (Los Angeles), 25(3): 70–81, 102–104, 1992.

Search through fashion and general magazines for clothing that can reveal wealth, social status, religious piety or political authority. Cut out the images of the clothing and place them on a chart under the designated categories and explain why you think these types of clothing fall into the categories in which you have placed them.

• Societies typically have images or acts that are said to protect an individual or guard against unforeseen evil. Among the Hausa of Nigeria, the various motifs on the "Robes of Honor" were considered to have protective properties. In your culture, are there objects with protective properties? A rabbit's foot, a horse shoe, and crystals are used to bring "good luck," or conversely they have properties that protect against "bad luck." With classmates name as many "protective" charms as you can that have been used in the past and are being used today. Use resources in your school library to determine the ethnic origin of these "good luck" charms and why they were used.

Study Sheet

1 Traditionally, who were Hausa embroiderers and how did they learn the art form?

2 What purposes do Hausa robes serve?

3 What are the names of the two motifs found on the male prestige gown?

4 Many of the symbolic motifs found on the robes are not unique to the robes, but can be found on other objects. Name other objects that might have the same motifs.

BaKongo Crucifix

The BaKongo and Christianity

BEFORE the arrival of the Portuguese in 1482, the *BaKongo* Kingdom was a powerful state whose influence was felt over a large geographic area. The kingdom controlled six provinces, and its capital was located in what is now Sao Salvador, Angola. The Portuguese, under Captain Diego Cao, arrived in the BaKongo Kingdom and were soon followed by Catholic missionaries in 1490. Within a year Mani Kongo, the king of the BaKongo people, was converted to Catholicism. He took the Christian name João I, the name of the Portuguese king.

With the help of Portuguese artisans, the BaKongo built a stone cathedral and monasteries, and established schools. The Portuguese brought in priests and everything needed for Catholic religious worship. Imagine the influx of images of saints, ornaments for the church, and crosses.

It would appear that Roman Catholicism had a strong hold on the BaKongo for approximately two hundred years. However strong the Christian religion may have been in this region, the BaKongo belief in Roman Catholicism was most often combined with indigenous religious concepts and practices. This version of Roman Catholicism was for a time acceptable in Rome even though it differed from mainstream Roman Catholicism. Some say, however, that the BaKongo were not seeking personal salvation through Christian faith, but were simply supplementing traditional religious beliefs and sources of power controlled by ancestral and nature spirits. King João is said to have seen Christian baptism as an initiation into a powerful cult. Following a war with the BaKongo people in 1665, the Portuguese and the missionaries withdrew from the country.

After the Portuguese left, many of the BaKongo returned to their traditional religions but integrated Christian symbols into their rituals. *Crucifixes,* which are crosses that include a representation of the crucified body of Christ, became symbols of power to the BaKongo, possibly because the objects had possessed power for the Portuguese. Called *nkangi,* crucifixes were handed down from ruler to ruler as a part of a chief's regalia.

At first, objects associated with Christian worship, particularly crucifixes, were exported to the BaKongo areas from Portugal. After a time they were copied faithfully by African artists, who also replicated other devotional objects, such as rosaries. Eventually BaKongo artists made the facial features of Christ on the cross more like those of Africans.

BaKongo Crucifix

Are you familiar with the symbol of the cross? The cross, in its Euro-Western Christian context symbolizes a sacrifice through which humankind won spiritual salvation and redemption. For the BaKongo, crosses became symbols of authority, objects for healing, **oracles,** and hunting **talismans.** An *nkangi* gave the clan chief the power to swear oaths, punish oath-breakers, and to judge fairly at trials. Traditional healers would rub the *nkangi* against the diseased portion of the person's body. This act was believed to release the medicinal properties of the *nkangi* and cure the sick. When a person died, the *nkangi* would be used to free the dying person from the torment of evil spirits. These crucifixes, or *nkangi,* are examples of how religious beliefs and practices from two cultures (traditional BaKongo and European Catholicism) can be combined. This mixing of form and function is called *syncretism.*

Examine the crucifix shown here. Notice how the central figure has been represented with outstretched arms, overlapping feet, and a head tilted forward. This is a conventional representation of the crucified Christ. Even though the body shows the hallmarks of a European-style crucifix, the facial features are clearly African. What other aspects of the body recall traditional European crucifixes? Notice the linear incisions for the rib cage and the folds of the loin cloth.

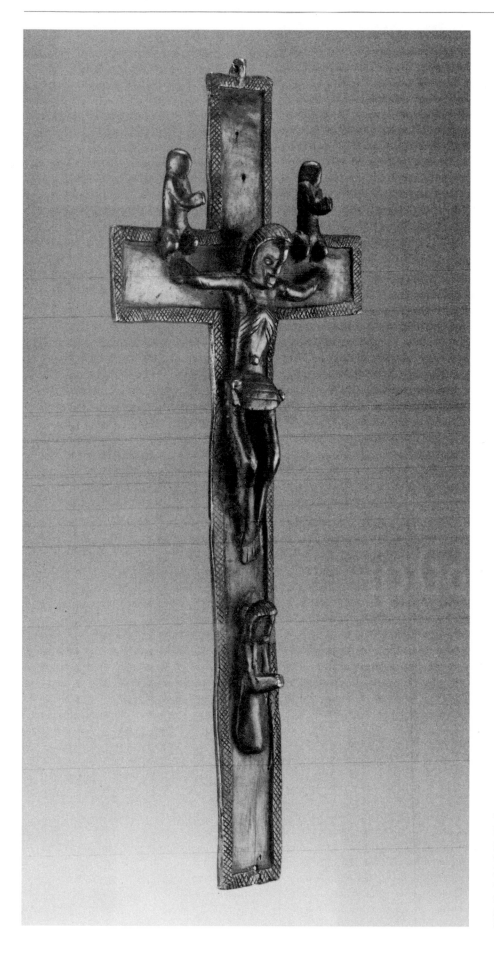

The border of the cross itself is decorated with **cross-hatch** patterns. Four praying figures are attached to each arm of the cross. The ones on the top of the cross are sitting while the one on the bottom is kneeling. It is not clear who these four figures represent. It has been suggested that the figures on the extended arms of the cross represent the two thieves crucified with Jesus. The image on the upper part of the cross is said to represent an Apostle or God. The figure at the bottom of the cross may represent the Virgin Mary or another holy woman.

Generally, BaKongo crosses and crucifixes were made of metal, wood, or a combination of both. With the exception of a few crosses in forged iron, most metal examples were cast in copper alloy. They were between four and eight inches tall. The design of the BaKongo crucifixes were probably inspired by Spanish crucifixes of the fourteenth, fifteenth and sixteenth centuries.

To cast the metal, BaKongo artists used the open mold technique, which is said to have been of European origin. Liquid alloy was poured into a wood block mold. Once cast and cooled, the surface of the crucifix was then polished and decorated with hatchings and other geometric designs. Metal working was a distinguished profession among the BaKongo. The smithy where crosses were made was considered a sacred place.

The crucifix increased the way the BaKongo could tap into the sources of power controlled by ancestral and nature spirits. BaKongo peoples, Congo and Zaire, *Crucifix (nkangi kiditu)*, late 17th or early 18th century. Copper alloy, H: 13", (33 cm). Gift of Ernst Anspach. Photograph by Franko Khoury, National Museum of African Art.

World Art Connections

• In the world of art there is often an exchange of ideas and forms between cultures. Pablo Picasso, Amedeo Modigliani, and other French modernists used aspects of African forms in their works. Locate Picasso's painting *Les Demoiselles d'Avignon*, 1907. Heads of three female figures were inspired by African masks. In his sculpture, Modigliani borrowed the elongated face and nose from the Fang masking tradition. The Fang are a people who live in parts of Southern Cameroun, Equatorial Guinea and Northern Gabon. Their masking tradition consists of oblong white faces with lineal design, lines of arched eyebrows continuing into elongated lines of the nose. Modigliani incorporates these traits into the well-known series called *Head.*

Such use of African influences marked a turning point in the history of Western art. Adding non-European imagery was seen to be innovative as a means of expressing emotion and psychological dimensions. German expressionist artists of the early twentieth century, such as Ernst Kirchner, also incorporated imagery from African art into their paintings.

Locate artwork by contemporary African-American artist Renée Stout, who incorporates BaKongo aspects of art into her work. Stout is concerned with the spiritual content of BaKongo pieces in an effort to communicate a comprehensive understanding of Africa. She, like Picasso and Modigliani, does not replicate forms or copy actual art and artifacts, but incorporates formal qualities— aesthetic decisions artists make regarding form, color, scale, media, and so forth. In a work she calls *Fetish #2*, Stout presents herself

wrapped in the accoutrements of power and magic, as a life-sized **nkisi** figure. The BaKongo called their traditional wooden images of power nkisi. (They also called the Catholic paraphernalia *nkisi*.) Stout cast her own body in plaster and then painted the mold with several layers of black paint. She incorporates medicine bags, cowrie shells, and a glass-covered box, all formal aspects of some African sculpture. Stout has said that she created the figure to protect and heal herself.

Classroom Connections

• Even though historians have said that African art was and is predominantly a religious art, it is very difficult to categorize African art objects as religious or secular. In some instances objects have a role in both domains, while in others a ritual object can become secular over time. Though the key to understanding whether an object is religious or secular is to determine its function, African works of art may have multiple functions. How can these functions help us decide if a piece is religious or secular? Think about the different functions described for the *nkangi?* How many of these functions could be listed as religious and how many as secular? How does this object help us understand the relationship between religion and life among

Whether *Nkangi* were carved in wood or cast in metal, they were, as other BaKongo power figures, rubbed with camwood powder before or after use as an offering to the spirit invoked.

BaKongo refers to a group of people
who live in parts of Angola,
the Free State Congo, and Zaire.
The Congo, often referred to as Congo-Brazzaville,
is located on the west coast of Africa.
The Congo was a French colony until 1960
when it became independent.

the BaKongo? How does this object help us understand the belief systems of the BaKongo people?

• The BaKongo artists transformed the crucifix by giving it African attributes. A term for this transformation is Africanization. Adding attributes from one culture to the artistic expression of another is not uncommon. Discuss with classmates why you think this happens. Think of examples of Americanizations or Westernizations of non-Western art. Find an American image that you could Africanize and an African image that you could Americanize. Be aware that your choices are not made over time and within a cultural tradition that was oppressed or colonized.

What difference would such conditions make in the way influences are adopted from one culture to the next? Also think about the fact that there are numerous cultures in both Africa and the United States. What transformations would you make? Discuss why you would make these choices.

Resources

Museums

The National Museum of African Art, Smithsonian Institution, Washington, D.C.

The Metropolitan Museum of Art, New York, New York

The Snite Museum of Art, University of Notre Dame, Indiana

Books

Sieber, R. & Walker, R. *African Art in the Cycles of Life.* Washington D.C.: National Museum of African Art, 1987.

Snite Museum of Art. *Christian Imagery in African Art: The Britt Family Collection.* South Bend: Snite Museum of Art, 1980.

Study Sheet

1 Who was João I?

2 How did the *nkangi* become a symbol of power?

3 How were *nkangi* made?

4 How did the BaKongo peoples use *nkangi?*

Ethiopian Triptych

Painted Panels

THE Axumite Empire, situated in the north of what is known as Ethiopia, became one of the first nations south of Egypt to become Christian. The first king to convert to Christianity was King Ezana in 350 AD. Religious art inspired by Christianity in Ethiopia dates back to the early days of Christianity, though little has survived from before the fourteenth century. Like European Christian art, Ethiopian Christian art includes paintings on wood and illuminated manuscripts. Wall paintings were primarily made for churches as were painted panels. There were single panels, diptychs (a picture divided into two panels), and *triptychs* (a picture divided into three panels). Each panel and its raised frames were carved out of a single piece of wood. The panels of triptychs or diptychs were joined by strings or thin leather straps threaded through holes drilled in the sides of the boards. The artist primed the surface of the wood with gypsum and a binding agent containing protein, probably bone glue. Generally, the central interior panel of a triptych was covered with cloth before the primer was applied.

The colors, red, green, black and yellow, used in the paintings were created from pigments obtained from minerals, plants or coal, which were ground between stones in hand-mills and then mixed with a binder of animal protein. Blue was obtained from indigo, an herbal extract that probably was imported from India. Generally, there was no varnish applied to the paintings.

Fifteenth Century Triptych

Our Lady Mary with Her Beloved Son, the Ancient of Days, Prophets, Apostles and Saints probably painted by the monk Fere Seyon, a fifteenth-century Ethiopian artist who painted for the court of Emperor Zara Yaeqob, is an example of an icon, or religious, painting. Notice that this triptych includes inscriptions in each panel to indicate who is being represented. Mary and the Christ Child are in the central panel flanked by the archangels Gabriel and Michael and the apostles Peter and Paul. Do you recognize traditional Christian symbols found in European Christian art? Mary is holding a flower and the Christ Child is holding a dove. Beneath Mary is a series of half figures of archangels who hold swords, as do Gabriel and Michael.

Examine the right panel. Notice that it has four sections that depict biblical themes. Daniel at the top is placed in a circular frame with four animals in the corners, which represents Daniel's vision of the Ancient Days. The animals represent the four beasts Saint John the Evangelist said he saw around the throne of God. Other figures in the second and third sections of the right panel represent the prophets. The men on horses in the bottom section are the soldiers Saint Victor and Saint Theodore.

The left panel contains more portraits of apostles, saints, evangelists and the first bishop of Jerusalem. The bottom section of the left panel shows another man on a horse who is said to be Saint George. Standing beside him is Saint Alexius, "Servant of Christ."

These icons are taken from Eastern and Western Christian cultures. However, there are some aspects that make them representative of Ethiopian and also African art. The presentation of frontal images is indicative of the Ethiopian technique of representing good through front-facing figures and evil through profiles. There is little or no indication of landscapes or architectural structures, instead backgrounds are either covered with geometric patterns or divided into horizontal bands of color. Overlapping occurs but no spatial depth is indicated. Ethiopian artists also favored the use of hierarchical perspective, which is a pictorial device whereby larger figures indicate the most important individuals and the smaller figures the less important ones. Ornamental lines in black were sometimes superimposed around the figures.

Religious paintings were given special value and were placed in only a few Ethiopian churches. Wall paintings were placed in remote locations and panel paintings were stored in the sanctuary or secured in what is known as the treasure house of the churches and monasteries. Paintings of certain images—those depicting the Crucifixion, Christ, or the Mother of God—were covered with a cloth. They were rarely displayed during regular religious services but were exhibited on specific holy occasions or to intercede in times of drought or pestilence.

Ethiopian believers commissioned paintings such as this one and offered them to churches in order to insure the salvation of their souls. Fere Seyon, Triptych, Central Ethiopia, *Our Lady Mary with Her Beloved son, the Ancient of Days, Prophets, Apostles, and Saints,* 1445–80. Tempera on Gesso-covered wood panels, 24 13/16" x 40 3/16", (63 x 102 cm). Institute of Ethiopian Studies.

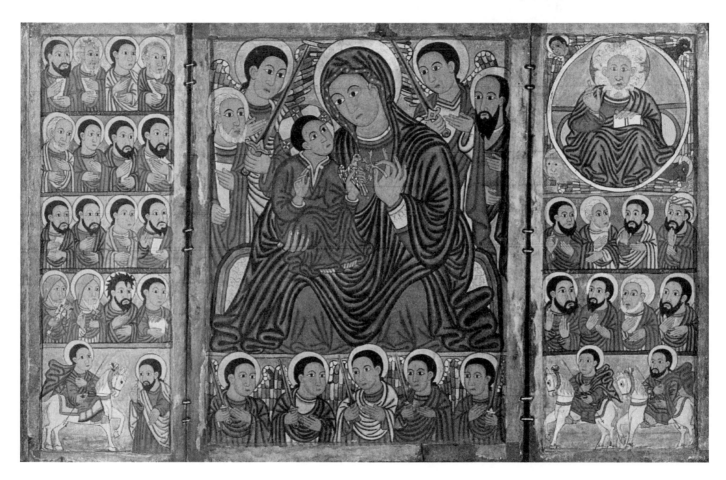

World Art Connections

● Ethiopian religious painting was greatly influenced by many different cultures, including Graeco-Byzantine religious art and Coptic and Nubian mural decoration. The Graeco-Byzantine impact on early Ethiopian art can be seen in the depiction of important events in the history of Christianity. The Nubian and Coptic craft of mural decoration was instrumental in initiating the widespread trend of mural painting in the thirteenth and fourteenth century monolithic churches found in the Ethiopian mountains.

One interesting aspect of Ethiopian painting is that the importance of people portrayed in a painting was determined by hierarchical perspective. This type of perspective has been utilized by artists in many different parts of the world such as Africa, China, and Europe.

In a twelfth-century French painting, *Mission of the Apostles*, Jesus Christ is the largest figure, with his apostles depicted in a smaller scale. An example of a Chinese scroll painted by Yen Li-Pen, titled *The Thirteen Emperors*, has characteristics of hierarchical perspective. The detail of Emperor Hsuan Ti shows him much larger, in more detail and in a darker colored garment than the other figures in the painting. Early Renaissance paintings and illuminations from the Middle Ages also used hierarchical perspective. An example can be seen in a panel by Gentile Da Fabriano, *Coronation of the Virgin*, in which the two angels depicted at the feet of Mary and Christ are represented in a smaller size, showing lesser importance.

Some Egyptian wall paintings like those of Ethiopia were divided into sections, however, their purposes were slightly different. In the Ethiopian example the ascending sections were there to reinforce the levels of importance of the figures in each section. In the Egyptian murals particularly in the tomb of Nakht, in Thebes, sectioning of paintings was used to create zones of action. Look for a reproduction of these murals and compare the ways in which subjects are depicted.

The triptych represented was dedicated to Mary of Zion and is said to have come from one of the oldest churches in Ethiopia, the ancient metropolitan cathedral at Aksum. This church may have been founded in the mid-fourth century by Ezana, the first king of Ethiopia to convert to Christianity.

Classroom Connections

● Art historians often try to determine when the artwork under study has been influenced by art from other cultures. Working in a small group, compare the triptych *Our Lady Mary with Her Beloved Son* with Madonna and Child images from other time periods. If possible locate the following specific paintings: the Byzantine thirteenth-century panel, *Enthroned Madonna and Child*, the fourteenth-century painting by Giotto, titled Madonna and Child, and the fifteenth-century painting by Gentile Da Fabriano, *Coronation of the Virgin*. Compare the central panel of the Ethiopian triptychs to these compositions and the styles used. Consider the placement of the figures, the relationship of one figure to another, who and what has been included in the painting, and the gestures that the figures are making. For style, consider

The Ethiopians infused Christian images with details from their own lives and practices. For example, in Ethiopian depictions of the crucifixion, the figures express their sorrow at the death of Christ by sharply bending their arms upward with hands resting on shoulders. This is a typical Ethiopian expression of grief.

Resources

Books

Grierson, R. *African Zion: The Sacred Art of Ethiopia.* New Haven: Yale University Press, 1993.

Isaac, Ephraim. *The Ethiopian Church.* Boston: Henry N. Sawyer, 1968.

Articles

Piechocinski, M. S. "The Iconography of Ethiopia: A Review of the Styles, Themes, Techniques, and Influences in an Historical Perspective," *Sacred Art Journal,* 10(3): 95–112, 1989.

Study Sheet

the ways in which clothing has been rendered, colors used, painting technique and the type of brush strokes, decorative elements, and the treatment of backgrounds. Next give a detailed description of what you see in the central panel of the Ethiopian triptych. Now work together to speculate on possible influences among the cultures and periods.

1 Christian Ethiopian panel paintings had three different forms. Name them.

2 Who was King Ezana and what did he do?

3 Generally, what was the content of Christian Ethiopian paintings from the fifteenth century?

5 Objects of Spirit, Power and Glory

Igbo Ikenga

Spiritual Object

IKENGA is a term used by the Igbo people of the north central region of Nigeria that relates to the principle of reincarnation. This belief in rebirth is a central idea in many African religions. The Igbo also believe that unborn souls shape their destiny, before they incarnate in physical form, through an agreement with their *chi,* or personal guardian spirit. The Igbo believe that success is important and that individuals are responsible for their own achievements in life.

The term ikenga also is used to describe a type of sculpture that takes the form of a personal shrine and relates directly to the spiritual concept of ikenga. Ikenga images vary greatly in height, from about a foot to the height of an adult male, and they vary in surface decorations. The smaller sculptures are for individual owners, usually men; larger ones are generally connected to a community. However, when a man owns a large ikenga, it is a sign that he is wealthy and has great status. Ikenga are generally carved from wood and in some cases have headdresses supported by two horn symbols.

African wood carvers, including Igbo carvers, usually use freshly cut green wood. European wood carvers, in contrast, tend to use dried, seasoned wood. Most Nigerian carvers soak their wood in water to keep it moist and soft throughout the carving process. The smooth, planar style of carving is accomplished with an adze and chisel for preliminary shaping and with a knife for details and finish.

Once the wood is dry the ikenga is painted. The face is generally painted white with details highlighted in black. The body is painted with black designs on a white or light background, which correspond to the *uli,* or black pigment designs used on houses and worn by men as ornaments.

Ikenga Carved Statues

Ikenga usually represent a male figure seated on a stool with horns projecting from the top of the head. The horns represent those of a ram because the animal was ferocious when provoked. The figure holds objects in each hand, sometimes a head, a skull, a tusk, a staff, a flute, or a pot of palm wine. Ikenga may be ornamented with scarification marks and body painting.

Compare the two examples of ikenga shown here. One is abstract and the other is representational or humanistic. The abstract ikenga (Figure 1) has legs projecting from a spool-shaped body. *Ichi marks,* which let us know that the owner is a titled man, are present on the forehead. The horns on the figure's head are relatively straight and there is a pipe in the mouth. The body or spool-shaped section is covered with geometric patterns.

What is the figure holding in the more realistic example (Figure 2)? This seated figure holds a knife or cutlass in the right hand and a tusk in the left. Curved horns on the top of the head seem to be attached to a headdress. The face has been painted in great detail, with white eyebrows and the nose and mouth outlined in a dark color. The neck is covered with *uli* patterns. Chest scars are carved in relief and refer to the rank of the individual.

The ikenga is a symbol of success and represents a man's achievements in life. It symbolizes the strength of a man's right hand, which he uses to cut a way for himself through life, to succeed in farming, fishing, hunting, war, and trading.

Ikenga statues identify the social achievements of men. Masculine characteristics are exhibited through the knife held in the right hand, the horns, and the figure's gestures. Symbols of success include the stool, knives, a victim's head, cap, ivory bands, and body decorations. The stool was a sign of high status because in the past stools were only used by titled men. The presence of a knife and a head symbolize aggression and a warrior's achievement. The knife is always held in the right hand because that is the hand used to hack one's way through life.

An elaborate figure holding a staff and a tusk indicates authority. These figures are usually large and were generally acquired by men upon their elevation to the highest ranks, or they may have belonged to the community as a whole. The tusk is supposed to refer to the ivory horn

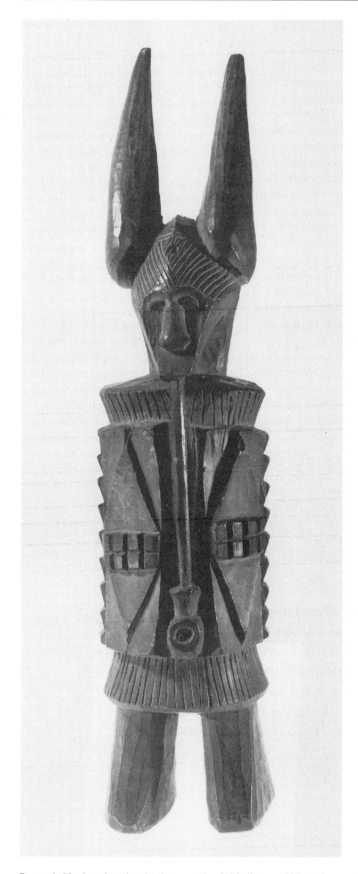 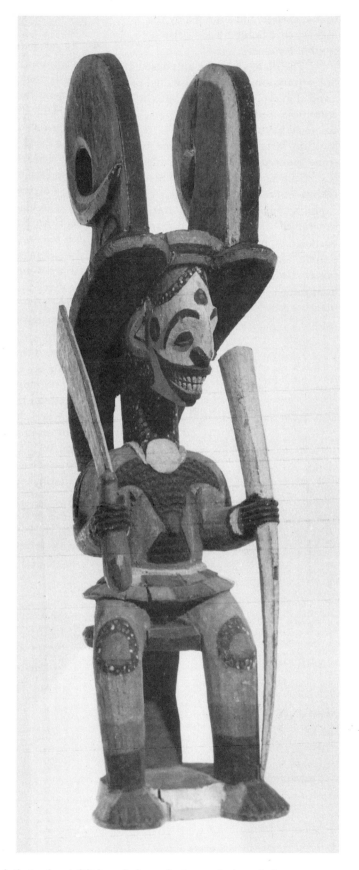

Figure 1 Notice the pipe in the mouth of this ikenga. What do you think that refers to? It is an independent ancestral symbol. Northcentral region, *Ikenga.* Wood, H: 29 1/4", (74.3 cm). UCLA. Gift of the Wellcome Trust. Collected by M.D.W. Jeffreys.
Figure 2 Men may own more than one ikenga in a lifetime for they can order a new ikenga to reflect a newly achieved rank and status. Awka region, *Ikenga.* Wood and pigments, 17 3/4", (45 cm). UCLA. Gift of the Wellcome Trust.

that is carried and sounded by the highest title-holders and is also a symbol for chiefs.

The ikenga may be purchased or commissioned by an individual or a social group. An individual might commission one after he has achieved his first major success in hunting, farming, title taking or in some other area. When a man dies his friends and family take up his ikenga and tell the story of his exploits and achievements. After his funeral, the ikenga may be discarded, buried, or spit into, acts which have societal significance. If the ikenga is not discarded, it is kept as a family heirloom.

World Art Connections

● As an identifier of achievements, and economic and social status, the ikenga is comparable to sixteenth-century northern Renaissance portraits. Hans Holbein, a sixteenth-century German artist, painted a double portrait titled *The French Ambassadors*, (1533). The French ambassador to England is depicted with his friend, a bishop. They are shown with an array of objects such as a celestial globe, flute, books, and compass, which refer to the pursuits of scholarly gentlemen. Other objects refer to the more somber side of life: death is symbolized by the sundial, the lute with the broken string, and the skull, which is cleverly rendered to be seen only from a certain vantage point. What about the clothing, postures, and scale of this work give an indication of masculine accomplishment? Think about the period—how many males were educated? Compare the symbology in the work with the ikenga. What metaphysical issues are raised in these artworks from two very distinct cultures?

● One convention of Western art prior to the twentieth century was the display of masculine power in depictions of men with horses. Locate examples of equestrian statues and paintings. What difference does the presence of the horse make in the works? How is power and glory shown? Find a reproduction of the ancient bronze equestrian statue of Marcus Aurelius. Who was this Roman ruler? Notice that he raises his right hand, perhaps as a gesture of authority, in the same manner that authority and power was invested in the right hand of the Igbo male.

In Van Dyck's portrait of Charles I the king is dismounted. Charles was an accomplished cavalier and is portrayed standing next to his horse with his right hand resting on a cane. How is this a representation of masculine prowess and authority? What do you know about Charles I's achievements? Can you make a comparison between this painting and other European equestrian paintings and Igbo ikenga? Explain.

The Igbo are said to have originated about a hundred miles north of their current home land in the Niger-Benue confluence some four to five thousand years ago. They speak a Kwa language that is different from their neighbors the Igala, Edo and Yoruba.

The concept of ikenga,
as well as its visual representation,
may have originated with the Igbo
and then spread to other Nigerian groups
such as the Igala.

Classroom Connections

• The ikenga is an object whose purpose is both utilitarian and aesthetic. As a utilitarian object, it acts as a personal shrine to which sacrifices and prayers are made daily. It is a portrait of an individual, much in the manner as the portraits of Marcus Aurelius, Charles I and Jean de Dinteville in *The French Ambassador*, which honor the men of power and praise their accomplishments. Can we place the ikenga in the same fine art category as the European portraits? If you were a curator of a museum would you consider the ikenga by the same criteria as the European portraits? What criteria do you think should be used? Why do you think art has a category known as "fine art"? Organize a panel discussion with your classmates. Prepare a short list of questions to ask panel members about how to determine what is fine art. Assign roles, such as curator of Western art, curator of non-Western art, African art scholar, Nigerian artist, art student, museum goer, and moderator.

• The ikenga has a number of attributes that identify it as an example of male power. Look at the ikenga and list the symbols you find. Think of qualities and symbols in your own society or culture that represent male power and female power. Identify and discuss these symbols. You may find that not everyone agrees. Why not? Once you have identified the qualities and symbols that represent your ideas of masculinity and femininity, draw an image that reflects your ideas.

Study Sheet

1 The ikenga figures have several attributes that relate to their achievements; name at least two.

2 How is this figure a symbol of male power?

3 What is the *chi* and how does it relate to the concept of ikenga.

4 Ikenga statues may vary from very abstract to fairly naturalistic, yet one characteristic is present in both. What is it?

5 Individuality and invention are encouraged among the Igbo. How does the ikenga give clues as to how this appreciation of individuality exhibits itself among the Igbo?

Resources

Museums
Fowler Museum of Cultural History, University of California at Los Angeles, Los Angeles, California

Indiana University Art Museum, Bloomington, Indiana

Menil Collection, Houston, Texas

University of Iowa, Iowa City, Iowa

Books
Boston, J. S. *Ikenga Figures among the North-West Ibgo and the Igala.* London: 1977.

Cole, H. M. & Aniakor, C.C. *Ibgo Arts Community and Cosmos,* Los Angeles: Museum of Cultural History, 1984.

Articles
Aniakor, C. C., "Structuralism in Ikenga—an Ethno-aesthetic Approach," *Ikenga,* 2(1): 1973.

———, "Igbo Aesthetics (An Introduction)," *Nigeria Magazine,* 141: 1982.

———, "Ikenga Art and Igbo Cosmos," *Ikoro: Bulletin of the Hansberry Institute of African Studies,* (University of Nigeria, Nsukka), 5(1&2): 1984.

Onyeneke, A., ed., "Ikenga Defined in Terms of Form and Concept," *Ikoro: Bulletin of the Hansberry Institute of African Studies,* (University of Nigeria, Nsukka), 5(1&2), 1984.

Yoruba Gelede Mask

Carving a Headdress

THE term *Gelede* refers to a men's association that holds a **masquerade** festival in marketplaces during planting season to honor the special powers of women. Gelede masquerades can be found among western Yoruba people of Nigeria and Benin. The masquerades are spectacles that involve carved wooden headpieces, cloth costumes, dances, songs, and drumming. Performance began sometime in the latter part of the eighteenth century among the Yoruba and later spread to Cuba, Brazil, and Sierra Leone.

Gelede masks or headdresses are still carved in contemporary times. Duga of Meko (1880–1960) was a woodcarver who apprenticed under a master carver in Ketu Yoruba, an important art center in Nigeria. Duga carved Gelede masks in the traditional Ketu style of broad, flattened heads with shallow interiors. (See Figure 2.) His paints, which consisted of nine colors, were created from chalk, wood, indigo vine, seeds, and other plants. The colors were used in their matte state or made glossy by the addition of a gum arabic substance. Duga applied his paints with the chewed end of a splinter of wood. He carved with a small and a large adze to block out the figures, a special chisel, and two knives for details. Using his feet as a vise, Duga would turn the figure round and round, right side up and upside down so that he could view it from all sides while carving.

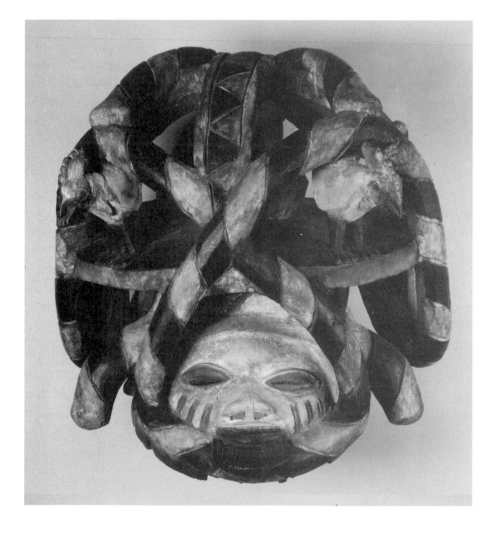

Gelede and Oro Efe Masks

The Gelede masquerade serves as both entertainment and ritual. As a ritual, the masquerade pays tribute to the spiritual powers of elderly women known as "our mothers," who are considered "the gods of society" and "the owners of the world." They are honored not only for their creative and procreative powers but also for their longevity, because women generally live to be older than men. Therefore, homage is paid to women so that the community can benefit from their innate powers. A woman's status is derived from her reputation as a trader and her own wealth, rather than from her husband's importance. This is why the masquerade takes place in the marketplace which is the domain of women and the setting of social and economic activity.

Figure 1 **Yoruba people, Nigeria,** *Efe/Gelede Mask,* **19th–20th century. Wood, pigment, metal. The Metropolitan Museum of Art. Gift of Usi Zucker.**

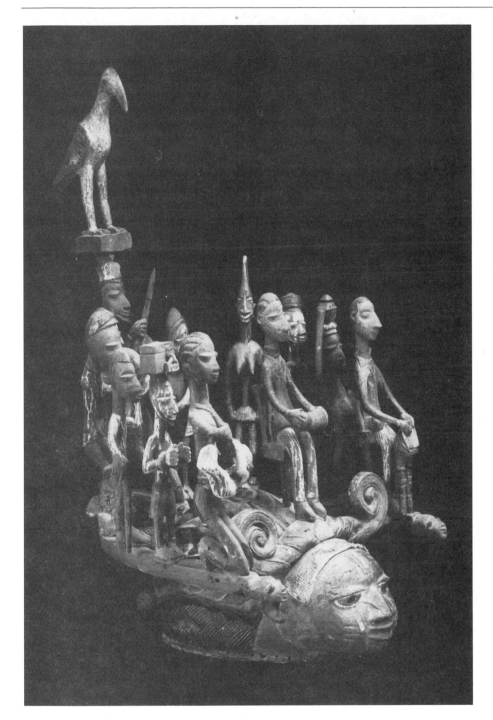

Figure 2 **Yoruba people, Nigeria,** *Efe/Gelede Mask.* **Wood, pigment, cloth, iron, metal, foil, H: 28 5/16", (71.9 cm). Indianapolis Museum of Art. Gift of Harrison Eiteljorg.**

Some make a distinction between the style of the Oro Efe and the Gelede masks. See Figures 1 and 2. Both basically consist of a helmet structure to which a superstructure is attached. The Oro Efe headdress, shown in Figure 1, consists of three parts: a veil, which hides the dancer, the cap, and the superstructure. The face on the Oro Efe is typically white, and the superstructure is painted in a variety of colors. The superstructures are often designed with curving circular forms associated with pythons, the crescent moon, or turban wraps. Sometimes animals such as birds, lions, and leopards may appear on the superstructure.

The mask shown here is probably an example of a headdress worn during the Oro Efe masquerade. A curvilinear form, perhaps representing a serpent, wraps around two birds that are standing on a platform. The mask's face has three scarification marks under the eyes, and a beard.

Because Gelede masks comment on the world, their superstructures depict a large variety of images that are often larger than the facial part of the mask. These superstructures may depict artists, craft persons, hunters, women traders, cult devotees, priestesses, courageous warriors, important dead personages, or mythic and historical events. The face, like that of the Oro Efe, wears a calm and composed expression, reflecting the idealized composure of the female.

Gelede masks also display visual information that reflects social changes and events. According to some, the Gelede headdress and the corresponding performances can be considered "newspapers" because they make comments on current events and on male and female roles in society, fashions, innovations, and achievements. Gelede performances also criticize antisocial behaviors, revealing the concepts, images, spiritual, and social roles of women in society.

The Gelede is performed in two parts. The Efe masquerade takes place at night and the Gelede masquerade takes place in the afternoon. Oro efe masquerades are singing male masquerades that represent the male status and masculine physical and spiritual power.

The Gelede mask's superstructure shown in Figure 2 speaks of communal responsibility. A profusion of images show people from all walks of life. Can you identify a prisoner carrying a load, a mother nursing, a preacher with his scripture, a man playing an accordion, a colonial soldier, an elderly man with a cane, a palmwine tapper, and an equestrian warrior who has an enormous crested bird on his head? The figures are placed on a U-shaped platform that ends in two human heads. The figures are elongated forms and all face the same direction as the face of the mask.

The figures were painted in brilliant colors. Evidence of blues, reds, white, and black still remain on the mask. This very intricately carved mask was probably carved from several blocks of wood and assembled with nails and screws.

Today superstructures incorporate movable parts attached with hinges that can be manipulated with strings. Some masks even incorporate more contemporary elements, such as flashlight bulbs, which are wired to batteries placed inside the mask.

World Art Connections

- The Yoruba painted their sculptures to make them appear more lifelike and to sharply distinguish various features. Ancient sculptures that we see in museums show no evidence or very little evidence of color, however, traditionally many sculptures were polychrome, just like the Yoruba Gelede masks. In ancient times the Aztecs, Mayans, Egyptians, and the Greeks painted their sculptures.

Whereas the Yoruba sculptures were made out of wood, the Aztecs and the Mayans created polychrome *terra cotta* funeral urns and figures. Aztec and Mayan ceramic figurines were coated with *stucco* and then painted, while the Yoruba sculptures are prepared with a *latex* coating before they are painted. These processes seal the wood and the terra cotta so that pigments do not soak in and diminish in brightness. Bright blues, whites, and yellows were the palette for Mayan and Aztec figurine sculptures and ceramic ware. Locate examples of painted ware from Teotihuacan, particularly funeral urns dating from 600–800 AD.

The Egyptians painted their limestone and wood sculptures. For example, a wooden funeral barge from the 12th dynasty would have been painted with realistic imagery and buried with the dead in the hopes that it would be used as transportation to the afterlife.

Find a reproduction of the painted limestone sculpture of Queen Nefertiti. Subtle details are painted onto a sealed ground.

Ancient Greek marble, terra cotta and limestone sculptures were painted many times with colors that might seem out of place, for example a beard might be blue. The skin of the individuals depicted in the sculptures was usually left the natural color of the stone.

The snake motif in the context of the Gelede masquerade is a metaphor of certain supernatural powers. Ogun, the *orisha* of iron and war, controls snakes, and Ogun Yoruba priests dance with snakes draped around their shoulders.

In Yoruba society it is believed that women possess an extraordinary power that is equal to or greater than that of the deities and ancestors. The Yoruba view women as healers and as guardians of morality and social order.

Resources

Museums

American Museum of Natural History, New York, New York

Indiana University Art Museum, Bloomington, Indiana

Indianapolis Museum of Art, Indianapolis, Indiana

Metropolitan Museum of Art, New York, New York

University of Iowa Museum of Art, Iowa City

Books

Drewal, H. J. & Drewal, M. *Gelede: Art and Female Power among the Yoruba.* Bloomington: Indiana University Press, 1990.

Classroom Connections

• Many works of art throughout history commented on social conditions and community situations. What social or community activity do you think is being depicted in the Gelede mask? Speculate as to why the Yoruba people would find this particular representation important in their society. What commentary does the mask make?

Work with a partner to identify European artworks that include social commentary. You may notice that more works of this nature. such as *The Roast Beef of Old England* by William Hogarth or *Raft of Medusa* by Theodore Gericault, seem to be paintings, drawing, and etchings, rather than sculpture. What sorts of social issues are portrayed in the works you found? Discuss with classmates how to compare the Western artworks with the Gelede mask. On what will you base you analysis? How will you know your speculations are viable?

• Make a list of various community or social activities or situations, for example, people playing cards, or children playing in the park. Discuss the list and, in groups, choose which activities and situations you would like to depict. Select a scene that you might witness in your everyday life or select a social issue about which you wish to make a statement. Create the figures that would be a part of this scene using wire and objects you can attach. Assemble figures into a scene to complete the wire sculpture.

Study Sheet

1 How did the Gelede cult comment on society?

2 What is an important purpose of the Gelede cult?

3 Find three reasons why women are powerful in Gelede tradition.

4 In your opinion, what would be some iconographic differences between the superstructures of traditional masks and more contemporary ones.

6 Memorial Effigies: Remembering the Dead

Mijikenda Grave Post

Kigangu

MIJIKENDA is a group of languages which are spoken by nine distinct groups of people. The Mijikenda people are semi-nomadic and live along the coastal regions of southern Kenya. They practice slash-and-burn agriculture and relocate their villages when they have depleted the soil.

Mijikenda-speaking peoples make a grave post called a **kigangu** (pl.*vigangu*). Very few wood carvers make them and, when they do, more than one artist participates. The wood chosen must be hard, long-lasting, and termite-proof. Before cutting the chosen tree, the carvers perform a small ceremony in which they reveal the name of the deceased elder and request permission to cut the wood for the grave post. The carvers follow ritual practices for felling the

tree and carving the post. Then, patterns are drawn on the wood, carved out, and later filled with alternating blue and white plaster. The gravepost is then painted with black, white and red latex-type **enamels.** Black colors are derived from charcoal, or soot, white from dried hyena dung or snake's urine, and red from red ochre. They are then mixed with fat to create the latex consistency.

Mijikenda Grave Posts

Vigangu function as part of a male secret society known as **Chama ya Gohu.** Only rich and influential male elders who were grandfathers could be a part of this society. The Mijikenda grave posts are reserved for medical practitioners, holy men, and the members of this secret society.

A kigangu is only necessary if the spirit of the deceased is said to be troubled in some way. The posts are usually carved and erected on the advice of a **diviner,** when an ancestor is said to be causing trouble to the living or when a brother, son, or grandson is visited in a dream by the spirit of the deceased. The kigangu was not just a memorial to the dead, but served as a place where the deceased elder's spirit could be called upon in time of need.

The kigangu had other functions. It could stand as a grave marker; as a record of the deceased's life, sometimes indicating the

number of wives he had or the number of enemies he killed in battle; as a reminder of the power of Koma (spirit); as a bond between the living and the dead;as a resting place of a spirit; as a place of sacrifice; as a guardian of the right to honor ancestors; or as evidence of pride in the rites associated with ethnic heritage.

The post is carried with great care to the grave site by the members of the Chama ya Gohu society and placed in a prepared hole at the foot of the grave. The post might be place to face east, the direction from which the clan of the deceased traditionally originated, or west, the direction associated with death.

The graves of elders were often situated together at the center of the **kaya** (the compound, or place of safety primarily for chiefs in time of attack) near the houses of the elders in charge of communal rituals. Less distinguished elders were buried in front of the doorways of their own houses to honor ancestors whose guidance helped during periods of crises.

The Mijikenda are a semi-nomadic people, and when they move, they generally take a smaller, simplified version of a kigangu to the new place. Though removing the original could cause misfortune, they sometimes carried the old ones with them to their next settlement. The maintenance of a kigangu does not extend beyond three generations. By then there is usually no one who can remember the dead when they were alive. Consequently their elder's power becomes negligible and the old vigangu are abandoned and allowed to return to nature.

Vigangu are usually between three and six feet high. There are two basic parts, the head and the body which are separated by a neck. The body is a thick plank of wood six to eight inches wide and approximately two and a half inches deep. These planks may be given rounded shoulders and arms that appear as horizontal cuttings.

The head of the kigangu may be rounded or flat. The flat-head kigangu is usually more abstract, but the

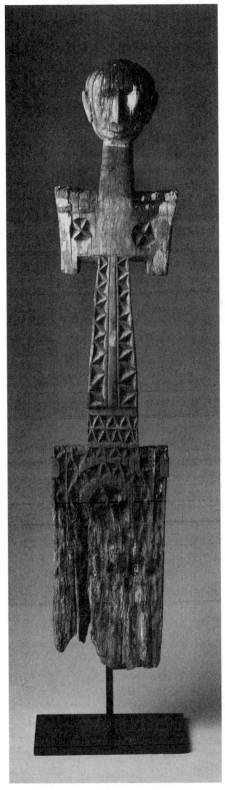 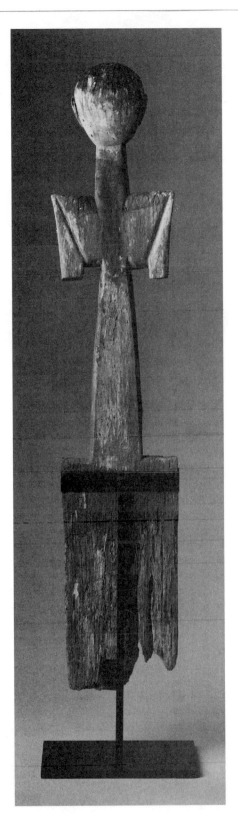

facial features are generally recognizable. Vigangu with rounded heads (such as the one shown here) are usually more realistic, with fine, well-carved features, and a concave face. The eyes are placed close together, the nose is long and fine, and the mouth is turned up as if it were smiling. The heads lack ornamentation.

The front surface of the body is decorated while the back rarely is. This may be because the vigangu were placed against a backdrop such as a house front or shrine wall, so there was no need to look at the back. The front surface is divided into symmetrical frames that contain a variety of geometric patterns, such as triangles, rosettes, and raised zigzag lines, which are engraved into the wood.

The geometric patterns may refer to objects and or to the human anatomy. The zigzag pattern, for example, may represent the decorations used by elders during important ceremonies, such as the triangle huts, rosettes, stars, and half-moons. When they relate to the anatomy, rosettes of indented triangles may refer to breasts and umbilical cords. The waist is indicated by a horizontal line.

There are traces of yellow, red, and white in the crevices of the kigangu's decorated areas. The process of placing the colors in the crevices has been likened to a *cloisonné*-like technique, in which surface decorations are set into hollow sections. The geometric patterns found on the posts are seldom duplicated on other posts.

This Kigangu is unusual because there is a suggestion of arms below the head.
Kambe, Kenya, *Kigangu* (front and back view). Wood, pigment, H: 44 1/4", (112.4 cm).
Eleanor Clay Ford Fund for African Art, Detroit Institute of Art.

World Art Connections

• The vigangu, like the early Greek vases, were used as grave markers. Greek **kraters,** which were ceremonial bowls, marked the graves of men; **amphora,** or store-jars, marked women's graves. Some of these vases were five feet tall.

The site on which grave posts are placed is called Kaya. Traditionally, the kaya was a village that was on the top of a high hill. These villages were constructed with an enclosure that had a system of palisades and narrow gates for defense. As village populations expanded and the threat of war was over, the people started living outside of its walls. The kaya continued to serve as a fortress, a ritual center, and a sacred place.

The height, inaccessibility, and pervasive cultural role of the Kaya recalls the Acropolis of the ancient Greeks. The Acropolis was a sacred hill above Athens. It was the place where the Greeks worshipped their gods and commemorated their heroes, just as the kaya has become a place where the Mijikenda people praise and commemorate their ancestors.

Classroom Connections

• African art objects are usually functional. However, they do not just function on one level, but have multiple functions which give them multiple meanings. Art historians usually look for these meanings and verify the information through cultural and contextual information. Review the functions of the kigangu. Determine, by using cultural information, corresponding meanings that might be associated with the kigangu. How do these functions and meanings compare with grave markers in your culture?

• Even though the Mijikenda choose a hard wood that is resistant to termites, they do not maintain the post. They are not repainted or repaired. After a number of generations the post is abandoned. Of the stages of transformation a kigangu might go through, which do you think should be valued the most? Work with classmates to determine the stages, the possible importance of each stage, and how the stages related to viewing the posts as art. Are we to value the eroded piece, value it for what it used to be, or value a new post in good condition? Discuss this issue and decide what you think must have been most important for the Mijikenda people.

The sizes of the vigangu vary from three to six feet tall. The importance of the person to be commemorated determines the scale of the sculpture.

If the traditional Mijikenda death ritual ceremonies and period of mourning are observed carefully, the spirit of the deceased will be satisfied. A grave post is not needed when the spirit rests peacefully.

Resources

Museums

Brooklyn Museum of Art, Brooklyn, New York

The Detroit Institute of Art, Detroit, Michigan

Hampton University Museum, Hampton, Virginia

University of Indiana, Bloomington, Indiana

University of Iowa, Iowa City, Iowa

Books

Friends of Bronze Community Art Gallery. *Mortuary Posts of the Giryama.* New York: The Gallery, 1978.

Wolfe, E. *An Introduction to the Arts of Kenya.* Washington,D.C.: National Museum of African Art, Smithsonian Institution, 1979.

————. *Vigango: The Commemorative Sculpture of the Mijikenda of Kenya.* Williamstown: Williams College Museum of Art, 1986.

Articles

Brown, J.L., "Miji Kenda Grave and Memorial Sculptures," *African Arts,* 13(4): 36–39, 88, 1980.

Parkin, D. J., "Speaking of Art: A Giriama Impression," *African Studies Program:* 1982.

Siroto, L. A., "Kigangu Figure from Kenya," *Bulletin of the Detroit Institute of Arts,* 57(3): 1979.

- In keeping with the idea of exploring the stages of transformation of the kigangu, describe what this kigangu could have looked like in its original condition. Redraw and paint the images to fit your descriptions. Now think of how you would design a kigangu for one of your ancestors. Sketch your ideas and share them with classmates. Do you notice common ideas? Now work as a class to design, and if possible build, a kigangu for a notable person in your culture who is no longer alive.

Study Sheet

1 Not all people had a kigangu erected in their honor. Who were the people they were erected for and why?

2 There are basically two major styles of vigangu. Describe the two styles and indicate the difference and similarities in form.

3 What is the Chama ya Gohu society?

4 The Mijikenda were semi-nomadic peoples, consequently they moved when the soil was depleted. What did they do with the vigangu?

5 Where were the vigangu placed? Why?

6 How did the carvers make the kigangu? Do you think their designs were meant to be aesthetically pleasing? Explain why or why not.

BaKongo Ntadi Stone

Soapstone Carvers

THE BaKongo are a people who live in northern Angola and parts of the Republic of Congo. They were once a part of a powerful kingdom that disintegrated when war broke out with the Portuguese over the slave trade toward the end of the seventeenth century.

The **ntadi** (pl. *mintadi*) refers to stone carvings made among the BaKongo of Angola.

Mintadi sculptures were made for approximately two hundred years and were first brought to Rome by missionaries during the second half of the seventeenth century.

The mintadi were carved out of **steatite,** a talc soapstone obtained from the ground or river beds. Soapstone is a soft, dense mineral that is silky to the touch. The stones may be gray, greenish, pinkish, or brown in color, and are so soft that they can easily be reduced to powder.

BaKongo carvers collected the soapstone rocks that were exposed in dried-out riverbeds during the dry season. On the surface of quarried stone, the carvers drew the object and then used small adzes and knives to carve it. The stone was worked when fresh and damp; it hardened upon drying.

Stone Carvings

Mintadi come in a number of different forms and poses. They represent both men and women. The women mintadi were usually represented with a child and were connected to female fertility cults. Male mintadi had a variety of poses and were placed on or near gravesites where chiefs or men of importance had been buried. They were, however, not created as simple grave posts or memorials to the dead. As objects they embodied the spirit of the dead ancestor.

Mintadi sculptures of males were depicted seated cross-legged on a pedestal, kneeling, or standing. The sculptures were supposed to show the physical character and wisdom of their subjects, conveying them in a way they may have preferred to be remembered. For example, a kneeling stone statue with extended open palms, placed on the tomb of an important person, probably meant the person was generous and was

respected and idealized for that virtue. The gesture could also refer to something that happened in a person's life. Someone who is weighed down with heavy problems and is terribly depressed might kneel before the community, palms extended, and explain the problem so that he or she might receive a new soul.

The stone statues showing figures seated cross-legged with the right hand under his chin and his left hand on his hip are the most common BaKongo memorial forms. The statue shown here is of this type, and is sometimes called a "thinking" ntadi. These kind of stone images were made for kings, chiefs, and nobility, often during their lifetime, and were kept until death, when they were used as memorial markers. They were not intended to be likenesses of the deceased, but symbols of the roles and characteristics for which they had become known. Rulers were depicted as well built and handsome, and wearing a distinctive cap as the badge of their authority.

The "thinking" ntadi represents a person gifted with the power of reflection, who thought on behalf of the people and who used wisdom to guide and protect them. Items on the figure, such as the four-pronged bonnet and necklace, reveal the rank of the individual. Notice that two prongs are missing from the four-pronged bonnet. The bonnet in its complete form represents the pattern of the claw. The claw points inward from each cardinal direction toward the center of a world in miniature. These claws are said to point to the four doors leading to the world: birth, life, death, and rebirth.

The statue depicts a figure seated cross-legged on a pedestal. This position is related to a proverb that says, "The elder seated cross-legged wishes to be saluted," meaning that the person who sits cross-legged demands respect.

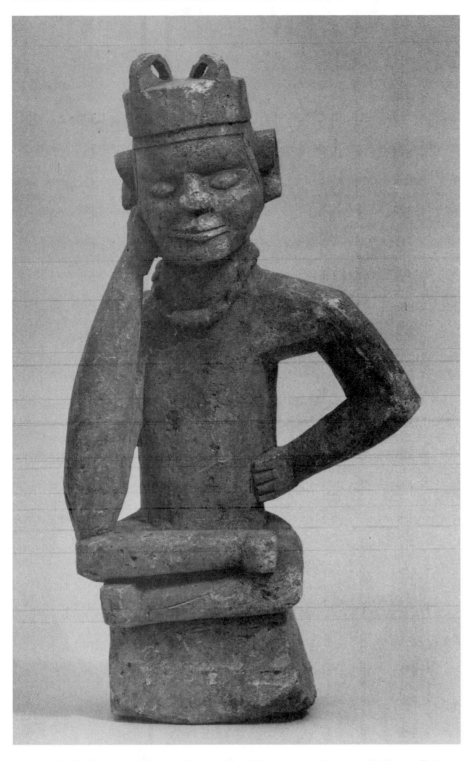

How would you describe the expression on the face? The head slightly bent to the right, the lips are sealed and the eyes are closed in a meditative pose. Sealed lips reflect the ideal composure of a chief, one who listens before speaking.

The right hand cupped to the face with the elbow resting on the right knee is a sign of sadness. It is said that the statue carries the sadness of its people into the other world. The left hand on the hip is said to press down negative events or evil.

Notice the necklace, which is another sign of kingship. This statue clearly represents an idealistic ruler who shows composure, restraint, and thoughtfulness, for it has all of the necessary attributes: it is seated on a pedestal showing a kingly gesture, and is wearing a necklace and a hat with a claw motif.

It is through the ntadi that the BaKongo seek the assistance of the ancestors, mainly for protection and direction in their daily affairs. Because cemeteries are generally placed at the entrances and exits of villages, they are therefore the focal point for the protection of the villages against evil spirits.

Among the BaKongo, cupping the hand to the chin is a sign of sadness. BaKongo, Zaire, *Ntadi*, 19th–20th century. Stone, steatite, H: 16 1/4", (41.3 cm). The Metropolitan Museum of Art, Michael C. Rockefeller Collection. Gift of Nelson A. Rockefeller.

World Art Connections

• The intentions of the mind are conveyed through gestures which have specific cultural meaning. Artists have always been aware of this and have used gestures to convey impressions or ideas. Even though gestures may be universal, the ideas conveyed may not. The hand cupping the chin in the mintadi figures represents sadness. A similar pose found in two Western works: a sculpture by the French artist Auguste Rodin sculpture, called *The Thinker* and in John Singleton Copley's painting of Paul Revere. According to Rodin, *The Thinker* is a poet. Copley's portrait of Paul Revere catches the silversmith in a moment of concentration, a moment of thought. Find reproductions of these two works. Although they reveal thoughtfulness, do you think either depicts sadness? Explain.

The gesture of crossed legs in the ntadi figures refers to the circle of life, the process of life, death and rebirth. A similar pose, known as a lotus position, is found in representations of the Buddha figures, from India. It is said the Buddha was sitting in this position when he vowed to attain enlightenment at the Tree of Wisdom.

The gesture of the hand on hip in the mintadi depicts the ability to press down negative events or evil energy. In the European Renaissance and Baroque periods, the same position for a male was an aspect of military stance and reflected self-possession and control, and conveyed success or defiance. Locate the early Italian Renaissance statue of David by Donatello, Frans Hals' *Portrait of a Man* and Rembrandt's *The Polish Rider*. Discuss with classmates the dangers of making comparisons between cultures, with respect to gestures depicted in art. Find examples in this book in which faces are depicted. Can you make a general statement about what the faces represent in African art? Why or why not?

In addition to depicting images of kings or rulers, ntadi may also depict occupations such as musicians, hunters, and doctors, or attitudes, such as silence, forgiveness or admonishment.

Classroom Connections

• Many of the mintadi poses are connected to proverbs. Proverbs are sayings that convey a culture's morals, values, or truths. Brainstorm for proverbs that your parents or grandparents have used, such as, "Don't count your chickens before they hatch," or "You can't get blood out of a turnip." Explain what these proverbs mean. Notice how chickens, blood, and turnip were used to help communicate a belief or philosophy. A number of cultures, such as the BaKongo, create visual images for proverbs.

Each ntadi figure
displays a particular set of gestures.
These gestures conveyed a moral wisdom
to the BaKongo and could be translated into a proverb.
These proverbs may have been used
to advise the community or they may have
reflected an everyday experience.

Resources

Museums

Metropolitan Museum of Art, New York, New York.

Books

Allison, Philip. "The Mintadi and Other Stone-carvings of the Congo." In *African Stone Sculpture.* London: Hund Humphries, 1968.

Thompson, R. G. & Cornet, J. *The Four Moments of the Sun: Kongo Art in Two Worlds.* Washington, D.C.: National Gallery of Art, 1982.

Some of the gestures in the ntadi statue in the photograph are signs and proverbs that help people to understand the message conveyed by the piece. The statue as a whole represents the ideal ruler and is connected with the saying, "I seat myself nobly, upon the circle of my life, weighing what is going on." How do the forms and signs in the statue reinforce the idea expressed by this saying?

● Proverbs usually refer to some characteristic of the objects or gestures depicted in the image. Select a popular American proverb. Think about how you might create that proverb in visual form. Create a papiér-mâché sculpture that expresses the proverb. Construct the sculpture in wire first and then complete the piece with papiér-mâché and paint. Have your classmates guess what proverb you chose, by looking at your sculpture.

Study Sheet

1 What are the characteristics of the stone that is used to create the mintadi and where is it collected?

2 The mintadi can be found in a number of different poses. Which is the most common, and who is it supposed to represent?

3 The ntadi "thinker" demonstrates what characteristics of a "thinking" pose? What else does this pose means to the BaKongo?

4 Why is the ntadi not just a grave marker?

5 What two ideas might a kneeling ntadi with extended hands palms open express?

Yoruba Carved Palace Doors

Olowe of Ise

OLOWE (1875–1938) was born in Efon Alaiye, a town northwest of Ise in Nigeria. He moved to Ise at a young age and became a court messenger of the Arinjale, or king of Ise. It is here that his carving career started. Arinjale, who was Olowe's first patron, commissioned him to carve veranda posts and doors for his palace. So great were his talents that other kings requested that he carve for them, and from the late 1800s to 1925 he carved for kings who lived within a forty to sixty mile radius of eastern Yoruba-land.

Olowe's reputation grew and after a while he had so many commissions that he worked with fifteen assistants who helped him carve veranda posts, doors, chairs, tables, among other objects. The greatness of Olowe's talents are sung in *oriki,* which are poetic songs of praise. Praise songs describe and preserve a person's lineage, personal history, and social achievements. According to the songs, Olowe was a great carver, warrior, and dancer.

Palace Doors

Doors and other sculptural forms, such as veranda posts, were carved for the palace of kings and chiefs. The doors turned on vertical hinges and were usually carved in low-relief, with the carvings facing the outside. The idea was to announce the power of the people who lived inside.

Doors were used not just as decorations but as historical records. They recorded special events and scenes from everyday life as they related to the royalty. The first of Olowe's sculptures to be exhibited outside of Nigeria (in London, 1924) are a set of doors that includes among other images the figures of two Englishmen. One sits in a hammock carried by two porters, while the other rides a horse. These images refer to two actual Englishmen, Captain Ambrose and Major Reeve-Tucker who served as commissioners for the Ondo Province at the end of the nineteenth century. The door is thought to commemorate an important first meeting in 1901.

Examine the doors shown here. These depict scenes of Yoruba court life and were commissioned by Arinjale of Ise. This panel is divided into two vertical and six horizontal panels, with indications that they were once painted. The vertical panels on the left have a series of thirteen paired faces, which are said to represent either captives taken in war or the sons of Oduduwa, the mythical first king and founder of the Yoruba people.

The right vertical panel is divided into six sections with scenes from the religious and domestic life of the palace. The second section from the top is the largest and shows a man mounted on a horse followed by two individuals, one of whom is a flute player. These men probably represent the equestrian's escorts. Olowe uses hierarchical positioning to establish the status of figures—larger figures are more important. Which figure, then, has more status?

The rider is a favorite image in Yoruba religious art. The carved figure on horseback is wearing a crown with a bird image perched on its top and a face of Oduduwa on the front. This could be a representation of a beaded crown (see chapter 2). His right hand is raised and his left hand holds onto an object that rests on his left shoulder. He may represent a king or possibly Obatala, one of the deified or idealized Yoruba ancestors who is considered the fashioner of human bodies.

Another unique aspect of Olowe's carving is that his figures have dynamic rather than static poses. Some heads and figures are turned to face the viewer, whereas others remain in profile with legs crossed. The top section of the door includes the wives of the king. The first two women could represent mature women, for they have children on their backs. The third woman could be a young wife or an attendant to the first two wives. The third section shows more

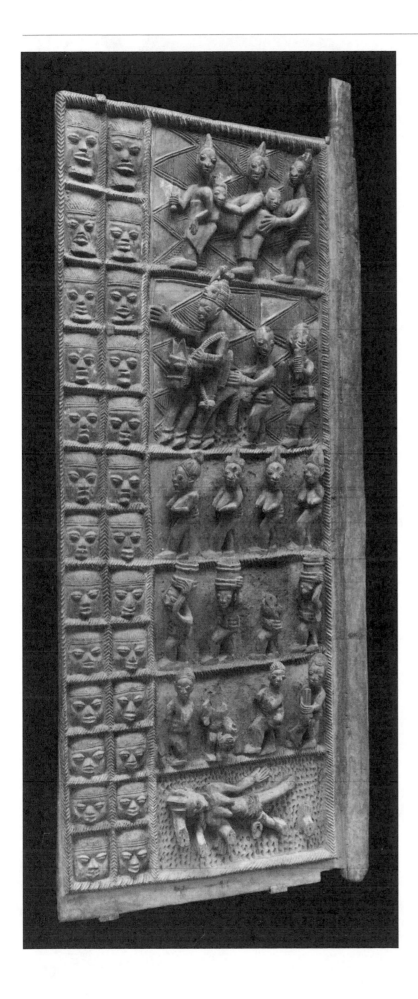

women in procession with their hands touching their chests in a sign of respect. The fourth section shows porters. The content of the last two are difficult to determine because parts of the carving are missing.

Backgrounds in many of Olowe's doors are textured. In this example, only the first two sections are textured. Olowe has used geometric patterns that combine textured and non-textured areas of incised lines. Each section of the door is framed with herringbone patterns. The artist has followed Yoruba conventions in facial characteristics, proportions, hairstyles, and gestures, but has also expressed his own unique vision. Olowe's innovations include his use of space, high relief, great attention to surface details, elongated figures, and detailed human faces. Most Yoruba doors are decorated with geometric patterns and/or figurative images that are in low relief.

Olowe's figures are in high relief. They stand out so far from the doors that they cast a shadow on the background. He introduced the practice of carving the figures to lean out at an angle from the door. The heads of the figures project as many as six inches when the feet lie against the door.

This door is from the Arinjale's palace at Ise. The door is carved out of a hard wood called iroko wood. Olowe of Ise, _Palace Doors_, 20th century. Wood, pigments, H: 87", (221 cm). National Museum of African Art, Smithsonian Institution. Gift of Dr. & Mrs. Robert Kuhn. Photograph by Jeffrey Ploskonka.

In their original form Olowe's door were *polychrome*, that is, painted in several colors, probably brilliant blues, reddish earth tones, whites, and black. Painting was done with the pliable fibrous end of a thin stick, birds feathers, or imported paint brushes. Usually the artist began with the lighter hues and finished with the darker ones. The reason is very practical; the artist did not want darker colors to bleed through the lighter ones. Thus white for the eyes, face, or mouth went on first, followed by darker colors for eye lids, hair, scarification marks, and so forth.

World Art Connections

• In the past many cultures decorated their architectural structures with doors carved in relief or with free-standing or relief sculptures. In the African context, elaborately carved doors were associated with an important entrance way. The same is probably true for carved or decorated doors in other cultures. For example, the doors leading to the entrance of the Parthenon in Greece were carved. During the Medieval period of European Christian art, bronze doors elaborately depicted scenes from the life of Christ.

In style, content and purpose Olowe's wood relief doors are comparable to several works from Europe. For example, the innovative character of undercutting the relief figures on architectural structures, to detach them from the background, was also a characteristic of the **pediment sculpture** of the temple of Artemis at Corfu in Greece, the bronze doors by Ghiberti, and those by Auguste Rodin.

Locate reproductions of the bronze relief doors titled *Gates of Paradise* by Ghiberti, which were carved between 1425 and 1452 for the Baptistery in Florence, Italy. They, consist of panels illustrating events. Ghiberti's doors illustrate stories from the New Testament and the figures appear to project out into space in front of the panel. Auguste Rodin also created a set of door panels in bronze that were destined for the Paris Museum of Decorative Arts. His doors, *Gates of Hell*, dated 1880–1917, have two panels showing tragic views of the human condition. One of Rodin's most famous sculptures, *The Thinker*, is depicted in the lintel of *Gates*. The figures are in high relief, with portions of their heads and bodies projecting away from the base of the door.

The set of Olowe doors that were exhibited in England in 1924, at Wembley, London, included a carved lintel and were installed at the entrance of the exhibit in the Nigerian pavilion.

Classroom Connections

● Until recently most artists of African traditional objects were anonymous. The artist was thought to be a faithful copier of conventions, was not innovative, and did not merit investigation or consideration. This was a cultural bias. Consequently, African art was appreciated only for its relationship to its social, cultural, and religious functions.

How does our lack of knowledge affect how we see African works of art? How does the identification of the artist, such as Olowe, affect our understanding and perception of African art? Does knowing who the artist is enhance our appreciation of the object? If you had to make a choice between purchasing a work of African art that was from an anonymous artist and one that was from a known artist, which would you purchase and why?

● Most African sculptures have been stereotypically described as simple, frontal, stiff, and symmetrical. Olowe of Ise's doors do not fit this description. Describe Olowe's doors. Pay attention to the times in which you have difficulty finding the appropriate words and phrases to describe what you see. Are there objects or figures depicted that are not recognizable to you? Talk with classmates about the process of looking at art from different cultures? How can such descriptions be made accurately?

● Many of the scenes in Olowe's doors refer to the daily life and activities of the royal court. Think of everyday activities that take place during a school day or in your community. Then, create a relief panel in clay that can be cast in plaster that depicts one community activity. Paint the panel. Put all of the panels together as a display and record of community activities.

Like all Yoruba carvers, Olowe worshiped and participated in the festival for Ogun, the deity of iron. Since his death, Olowe's family continues to celebrate the festival every September in his honor.

Resources

Museums

Art Institute of Chicago, Chicago, Illinois

Fowler Museum of Cultural History, University of California at Los Angeles, Los Angeles, California

The National Museum of African Art, Smithsonian Institution, Washington, D.C.

New Orleans Museum of Art, New Orleans, Louisiana

Books

Holcombe, B., ed. *Yoruba Sculpture of West Africa.* New York: Alfred A. Knopf, 1982.

Walker, R. "Anonymous Has A Name: Olowe of Ise." In Adiodun, R., Drewal, H J., & Pemberton, J., eds. *The Yoruba Artist.* Washington, D.C.: Smithsonian Institution Press, 1994.

Pemberton III, J. "The Carvers of the Northeast." Edited by A. Wardwell. *Yoruba, Nine Centuries of African Art and Thought.* New York: Harry N. Abrams, Inc., 1989.

Study Sheet

1　What was the purpose of carved wooden doors such as those created by Olowe of Ise?

2　What are the characteristics of Olowe's style of carving?

3　What are praise songs and what have they told us about Olowe?

4　In the door panels, which figure possibly represents a king? Explain your choice.

5　In what ways has Olowe honored the conventions of Yoruba art?

Mangbetu Jar

Mangbetu Potters

THE Mangbetu people are a diverse group of people from Central Sudan. They created high-quality pottery well before the arrival of the Europeans. The use of figurative elements in pottery only dates back to the latter part of the nineteenth century or the early part of the twentieth century. The creation of the figurative pots flourished from the end of the nineteenth century until the Second World War. These pots are apparently no longer being made.

Pottery is generally considered the work of women in Africa. In some areas, however, such as in northeastern Zaire, pottery has been known to be made by both men and women. When both men and women make pots, women tend to create domestic ware whereas men create the more decorative pottery.

Among the Mangbetu, figurative pots are said to be made by Zande and Budu men. When men and women worked together to create figurative pots, women built the coiled pot and men sculpted the heads attached to it.

Decorative patterns were impressed into the pot's surface. Traditionally, such surface designs were functional, because they prevented pots without handles from slipping. Figurative pots tend to have handles, and therefore surface patterns are purely decoration.

Mangbetu Figurative Vessel

The impetus for creating the *figurative pottery* may have come from European demand and/or from Mangbetu royalty commissions. The appearance of figurative vessels seems to coincide with the arrival and installation of the Belgian administration. Even though Belgians and other Europeans may have created a greater demand for the production of the figurative pots, the innovation itself must be attributed to potters from the city of Niangara who were already interested in sculptural elaborations. Mangbetu pottery may represent one of the first forms of tourist art, because they were made and sold to European visitors, so that the Mangbetu people could acquire cash to pay Belgian taxes.

Figurative vessels were also created for local use, particularly as prestige objects to demonstrate wealth and status. Important men apparently liked to carry figurative pottery around when they were traveling. A chief might present a figurative pot as a gift to important officers, both European and African, who were passing through his village—perhaps to curry favors from them.

There was a high demand for prestige objects, not only for gift giving. When a king or chief died, almost all of his precious objects were destroyed or buried with him. Thus each new ruler would have to commission new prestige items.

The production of this pottery only lasted for approximately thirty years. Why did the Mangbetu stop making figurative vessels? They were impractical as containers. Even though they had an open, flared mouth, they were not suitable for pouring, and they could not be used for cooking. The pots were neither made nor used for religious purposes. It is believed that the pots, despite their impracticality, may have been used for a short time as drinking vessels by important individuals. The most important patron of the figurative pots, Chief Okondo, died in 1915. This led to further decline in the need for these pots.

Mangbetu figurative pottery may be classified into two basic styles. The classic style, which comes from the northern regions, and a more abstract style from the south. The classic style is constructed out of the basic form of the nonfigurative pots made during the same period, having a round base with a long neck. The potter adds to this form a stylized head with an elaborate fanlike coiffure and a handle. The pot shown here is an example of the classic style.

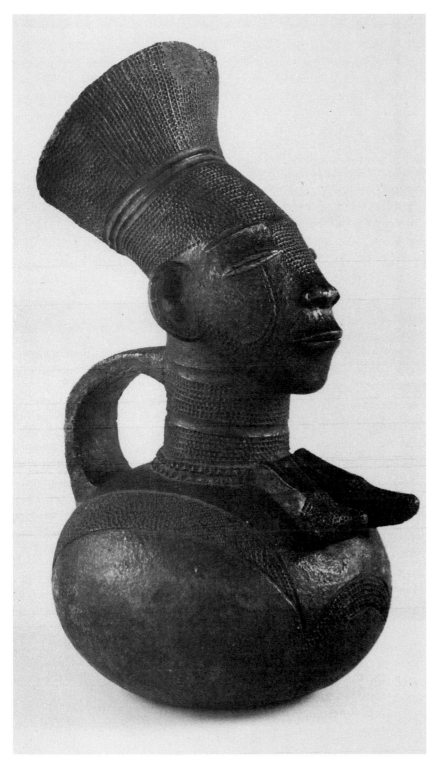

The Mangbetu figurative vessels served no other function than that of art for art's sake. They were kept as some say for "amusement." **Mangbetu people, Zaire,** *Ceramic Vessel.* **Terra Cotta, 10 5/8", (27 cm). National Museum of African Art. Acquisition funds donated by Donald B. Hirsch and Nicole F. Hirsch in memory of Elaine Newton Hirsch, and museum purchase. Photograph by Franko Khoury.**

The head of this pot is naturalistic. It depicts the typical hair style and elongated head characteristic of Mangbetu noble women. The Mangbetu were known to have bound the skulls of infant girls to create the elongated head. This Mangbetu figurative pot is a portrait of a Mangbetu noble woman. It accurately depicts the physical type, hairstyles, body ornamentation, and jewelry.

The surface of the pot is decorated with a stippled pattern in two bands around the neck. A pattern of quarter moons decorates the body of the pot.

World Art Connections

- The Mangbetu ceramic vessels are visually pleasing in two ways, the surface decoration and the figurative forms. In all parts of the world ceramic vessels have been decorated in a variety of ways. For example, Native Americans painted and incised the surface of their pots. The Greeks painted their vessels, Chimu of Peru colored their vessels with liquid called *slip.*

Most ancient ceramic pottery was created for utilitarian purposes. The Greeks, for example, created a variety of utilitarian ceramic vessels such as kraters, which were mixing bowls for wine and water; amphoras, which were storage jars, or the kylix, which was a drinking cup. The Chimu potters of Peru created pouring vessels for ritual and burial use. The shapes of Native American pots, like those of the Greeks, reveal their function as storage and cooking pots.

Locate images of Native American figurative pottery from the present day Pueblo peoples and the ancient Mogollon and Anasazi cultures. Find out for what purpose or purposes these pots were made? Utilitarian? Spiritual? Research the burial uses of Greek kraters and amphoras. Chinese potters also have a tradition of figurative ceramics.

The image of the upper class females with fan-like hairstyles can be found on Mangbetu pots, knives, figures, harps, pipes, boxes and other objects. The fan-like structure of the hair is created by wrapping string around the forehead and drawing longer hair around a basketry frame.

Classroom Connections

- When art historians look at various styles of art they try to determine when a style started, how long it lasted and when it ended. Within these questions is also the question of why it started or declined. Often the information must be pieced together from historical, economic, social, and political records. Review the text on Mangbetu figurative pottery and code the information under the headings "historical," "economic," "social," and "political." Write a short essay, based on your lists and other knowledge or resources you gather. Decide approximately when the figurative pots started to be created, what possible events initiated their creation, when their production started to decline, and what possible events caused this decline. Be sure you identify when you are basing your ideas on published material and when you are speculating.

Resources

Museums

Baltimore Museum of Art, Baltimore, Maryland

Peabody Museum of Art, Harvard University, Cambridge, Massachusetts

The National Museum of African Art, Smithsonian Institution, Washington, D.C.

University of Iowa Museum of Art, Iowa City, Iowa

Books

Schildkrout, E. *African Reflections: Art from Northeastern Zaire.* Washington, D.C.: Smithsonian Institution, 1990.

Articles

Schildkrout, E., Hellman, J. & Keim, C. "Mangbetu pottery: Tradition and Innovation in Northeast Zaire." *African Arts,* 22(2): 38–47, 1989.

Information about Mangbetu figurative pottery was first brought to the United States by American mammologist Herbert Lang. He was part of the Congo Expedition that was organized by the American Museum of Natural History shortly after 1908.

- Many of the Mangbetu traditional pottery forms, especially the non-figurative ones, included rounded bases repeated two or three times to create many-chambered water jars. Even the figurative pots were formed from a combination of sculptural elements, such as a round base, elongated neck, face, coiffure, and handle.

Look at a number of examples of pottery forms from different cultures. Identify and create a chart that shows the formal elements of the pots, followed by words that describe them, such as round base, flared neck. Create your own descriptors.

Sketch an idea for a figurature pot that combines three to four formal elements, each from a different culture. Hand-build the pot in clay and display it in class.

Study Sheet

1 What were the two possible sources for the creation of the Mangbetu figurative pots?

2 List at least three reasons why figurative pots were made.

3 Why did figurative pottery decline in the middle of the twentieth century?

4 Describe how the figurative pot is a portrait of the Mangbetu noble-women.

Senufo Oracle Sculpture

Divinely Ordained Artisans

THE Senufo people live in West Africa in parts of Ivory Coast, Mali, and Burkina Faso. They speak over thirty languages and dialects. They are a *matrilineal society,* predominately a farming people, but they also includes six distinct artisan groups. Artisan groups, which include blacksmiths, brasscasters, woodcarvers, weavers, and leatherworkers, are considered part of a divinely ordained social order among the Senufo. Each artisan group lives in its own settlement and is known by a particular name. Wood carvers, for example are known as *Kule.*

The Kule Senufo came from Mali, where they were reputed to have magical and supernatural powers. They specialized in oracle sculptures, or sculptures that "speak."

Equestrian Oracle Sculpture

Oracle sculptures are commissioned by diviners, who provided special instruction to the carver as to how the piece should be carved. A diviner acts as an intermediary between the ancestor and bush spirits, or *madebele,* and the living. Bush spirits are animate spirits that live in the fields, streams, and wooded areas. They influence people's lives in positive and negative ways. Because living people constantly disturb the domains of the bush spirits by farming, hunting, and engaging in artistic activities, precautions must be taken to appease them—which is the domain of the diviner. The bush spirits, therefore, become the source of the power of the diviners, because it is these spirits that diviners must contact to solve particular problems.

Senufo diviners are women who belong to the *Sangogo association,* a powerful women's society that has a counterpart in the men's association known as Poro. Whereas the Poro is responsible for the maintenance of political leadership, as well as male religious and social instruction, the Sangogo is responsible for safeguarding the purity of the matrilineage and maintaining good relationships between the bush spirits and the general population through divination.

Not all women are a part of the Sangogo association. There is usually only one per family line. Women who become part of the Sangogo enter either through inheritance or by being "caught" by a bush spirit. A woman knows she is "caught" by a bush spirit if she begins to experience misfortune in her life and her diviner indicates that a bush spirit wishes her to become a diviner.

There are basically two things a diviner must have: a group of assorted objects that may include miniature representations of blacksmith tools, knives, or rattles, and a display of oracle figures that stand about seven to nine inches tall. The oracle figures "speak" for the madebele, the bush spirits. Without these oracle figures, the diviners could not "hear" the madebele.

The diviner begins her ceremony by throwing assorted groups of small objects in front of the oracle figures. Once the objects are thrown the diviner is guided by the madebele to certain objects. The way the objects land presents a code to the diviner, for which she needs the help of the madebele to translate.

To facilitate the communication between the diviner and the bush spirits the diviner surrounds herself with things that will be pleasing to the bush spirits. One way of pleasing the spirits is through the aesthetic quality of the carved oracle sculptures that represent the madebele. Oracle figures may vary in style from fairly simple and abstract to intricately and delicately carved images. Only the wealthiest of diviners can afford the better sculptures. The quality of the oracle figures therefore speaks of the prestige and power of the diviner.

Oracle figures come in many different forms. They may be in the shape of male and female pairs or animals, and can be forged in iron, cast in brass, and carved in wood. The diviners must at least have a sculpture of a male and female pair. In addition to this, if they can afford it,

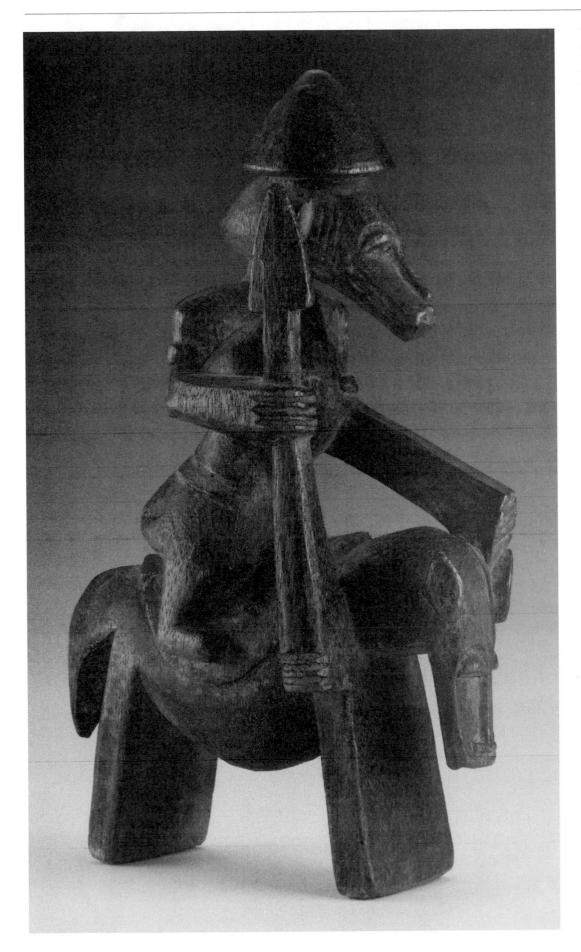

The horse is a powerful animal among the Senufo because it is connected with the Muslim crusades that took place in the nineteenth and twentieth centuries. Senufo, Ivory Coast, *Equestrian Figure*. Wood, H: 9 1/2", (24.1 cm). National Museum of African Art. Smithsonian Institution. Photograph by Eliot Elisofon, Eliot Elisofon Archives.

they should have an equestrian figure, which were known as "power owners." Horses are not indigenous to Senufo cultures. They were imported from the north, and for the Senufo have become a symbol of power, wealth and status. In the context of divination, the equestrian figure says that this diviner has powerful contacts with the bush spirits. These contacts are believed to be aggressive and efficient.

Examine the carved equestrian figure shown here. Notice how the figure is mounted on a horse whose forms have been simplified. The front and back legs are not separated but appear as block rectangles connected to the body of the horse. A tail is present, along with other details such as a saddle, ears, eyes, nose, and mouth. The figure mounted on the horse is a male leaning forward as if ready for battle. He wears a cone-shaped hat that represents the type worn by warriors or hunters. The face of the figures shows a typical Senufo style head that has a horizontally extended chin, narrow elongated nose, pursed mouth, and scarification marks on the temples. The right and left arms are bent at the elbow and have bangles on the upper portion of the arms, but are not the same length. The left is elongated and extends to touch the head of the horse, while the right one is shorter and holds a spear.

World Art Connections

- Surrounding oneself with valuable objects has always been a way of showing wealth, prestige, and power. The value of the objects in most cases is determined not only by their physical appearance but also by their rarity. For example, among the Senufo, possessing a horse, whether in sculptural form or as a live animal, was a sign of a great chief or wealth and power. Horses were rare, associated with some foreignness, and were considered exotic to the Senufo.

Many American and European paintings depict rare and exotic items. The presence of such objects in a family portrait attested to the prestige of that family. Locate the painting by John Singer Sargent titled *Daughters of Edward D. Boit.* Sargent painted two enormous blue and white Japanese vases. In the nineteenth century, possessing such items was an indication that the owner was wealthy, because these items were rare and had been acquired in a foreign land.

Another example can be found in the painting by Georges Seurat, titled *Sunday Afternoon on the Island of La Grande Jatte,* in which Seurat shows a woman in the foreground has a monkey on a leash. In the nineteenth century, owning such an animal as a pet was an indication that the people had traveled to some exotic land or had enough money to purchase such a rare animal. Can you locate other examples of exotica used to show prestige in Western art? In looking at non-Western art, how would you go about finding out which objects were considered rare and exotic in a particular culture? Why would it be a mistake to assume that something exotic in your own culture is also exotic in another?

Classroom Connections

- The Senufo equestrian figure has a spiritual and aesthetic purpose. As an aesthetic object, it was put on display to be admired by the clients of the diviner. As a spiritual object, it was said to hear and speak the messages of the bush spirits.

Should the equestrian statue be appreciated as an aesthetic object or as a spiritual object? For the Senufo people, the aesthetic quality of an object is intimately tied up with its function. Do the Senufo people judge art in the same manner as people outside of their culture? How might their aesthetic criteria be different from yours? Can you identify some instances in European and American art in which the aesthetic quality is spiritually tied to the function of an object? Discuss the above issues with your classmates. Find examples of art to share that help your discussion.

Some equestrian oracle figures carry arms. These indicate that the bush spirit itself is a prestigious messenger who is better equipped to deliver information.

All Senufo women
who enter the Sangogo association
are taught the fundamentals of divination.
However, not all become diviners.
Only a small percentage are able
to master the difficult
divination system.

Resources

Museums

Museum of Art, Carnegie Institute, Philadelphia, Pennsylvania

National Museum of African Art, Smithsonian Institution, Washington, D.C.

Books

Glaze, A. *Art and Death in a Senufo Village.* Bloomington: Indiana University Press, 1981.

Study Sheet

• The Senufo equestrian figure indicated the aggressive power and strength of both the owner and the bush spirits who would be addressed for assistance. Think about the ways in which symbols or *icons* are used in contemporary Western advertisements to persuade clients to buy products? An example might be the wings that appear on the heel of Nike tennis shoes. This icon was taken from a Greek myth about the winged goddess of victory. This goddess was usually shown flying with a palm branch or laurel wreath in her hand. Her job was to hold the laurel wreath over the head of the victor. Could the wings also refer to Mercury? Atalanta? Look up Greek and Roman mythology for other associations.

With a partner look through popular magazines and cut out examples of advertisements that use visual icons. Share you findings with classmates, and as a group select one for further research. Write a letter to the company to find out the source for the icon and the rationale for using it in advertising.

1 What are the madebele? Why are they important in Senufo society?

2 What is the purpose of a diviner? Who were diviners?

3 Why is the equestrian figure a sign of wealth and power?

4 Of the six groups of artisans in Senufo communities which one refers to wood carvers?

Nkisi N'kondi Statue

Creating a Nkisi

THE *nkisi* (plural is *minkisi*) is a statue used by the BaKongo *nganga*, who is a magician, witch, chief, and public diviner or prophet. The creation of the nkisi is a collaborative effort between the nganga and the carver. The carver creates the wood foundation on which other accoutrements, such as nails, medicine bags, or cloth, will be added later by the nganga. The carver usually does not know for what specific purpose the foundation will be used, but shows imagination and skill in how hair, the facial features, and feet are executed. A carver is either commissioned or produces a number of figures that are then sold in the market-place.

Nkisi N'Kondi

Initially, minkisi figures were misrepresented as *"fetishes"* by Europeans in the nineteenth and early twentieth centuries and were also considered objects used for destructive purposes. Between 1885 and 1921, Europeans colonizers saw that the nkisi were crucial to the BaKongo resistance. Consequently, Roman Catholic missionaries burned thousands of them and carried some of them to Europe as evidence of **paganism.** Many of those brought to Europe were stripped of their accoutrements because they were thought to be indecent.

The sculpture itself is just a piece of wood. For the object to become *nkisi* it must be constructed by the addition of songs, dances, and medical ingredients such as soils, ashes, herbs, leaves, and relics of the dead. Many people participate in the ritual of construction through dancing, drinking, and feasting. The celebration sometimes last for days. Once the ritual is over, the nkisi is put away, usually in a basket, in the roof of the owner's house or in a special house of its own.

The nkisi medicines may consist of musical instruments, strips of cloth, feathers, pieces of raffia, and sacks of herbal substances. Medicines may be placed in the head, in the belly, on the back or between the legs of the figures. Wherever they are inserted they are sealed in place with resin. Notice how some nkisi medicines are also worn on the outside in the form of sacks, shells, or horns.

Minkisi come in many forms and have many different functions. Each kind has a specific name. Minkisi can be categorized into two basic classes, those "of the above" and those "of the below." The **nkisi n'kondi** is an example of one "of the above" because it is associated with the earth and the waters. The purpose of the nkisi "of the above" was to maintain public order, seal treaties between various groups, and identify and punish criminals.

It is the area of identification of criminals that puts the *nkisi n'kondi* in the category of objects that revealed the unknown. The term nkisi refers to the figure itself, while kondi is related to a verb that means to hunt and seek out the unknown—usually witches, thieves, adulterers and other wrongdoers. It was the nganga who acted as diviner, healer, and judge and who owned the nkisi. They were the ones who it was said could communicate with the dead, to be able to see hidden things.

At least two elements on the figures—red tail feathers and mirrors—aid its pursuit to uncover secrets. Red tail feathers, which were associated with the diviner, come from the parrot who was said to "speak" or to "reveal secrets." Mirrors, which were used in the eyes of many BaKongo magic images, represented the supernatural abilities of the diviners to see into the world of spirits and look into the future.

The basic form of the nkisi in the photo is that of a standing male with his right hand raised and his left hand on his hip. The raised right hand probably held a knife or a spear at one time. The figure leans forward slightly. He has a European-style hat on his head. This nkisi is exceptional because it has as many as a dozen medicine sacks, five of which have been enclosed with mirrors: one on the belly, one in between the legs, one on the right elbow, and two on the back. These packs enable the nkisi to see witches that might come from any of the four directions. The figure has numerous other bundles. One, called a medicated collar, is placed around the neck.

The face of the statue has a dark **patina,** or fine surface texture, through which we can see painted red and white lines under the eyes. These lines represent the tears that come with death. The figure was at one time whitened with clay. The eyes, which are covered with pieces of glass, are open, showing the pupils. The mouth is open as if ready to speak. This nkisi probably represented a powerful figure because it holds the medicine kit that belongs to the nganga, has a large number of medicine sacks, and carries the seedpod, which was probably used for divination.

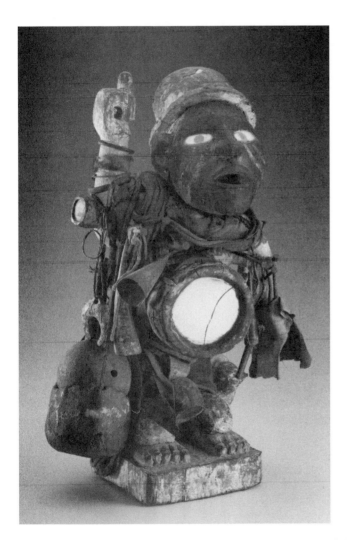
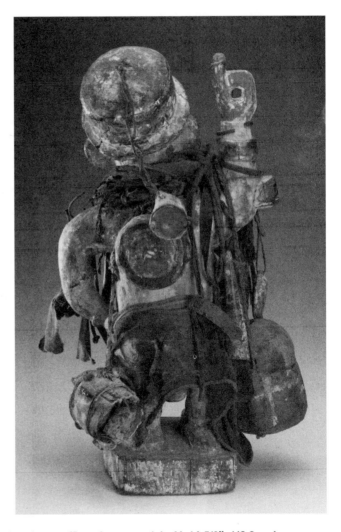

BaKongo, Congo and Zaire, Nkisi N'kondi (front and back views). Wood, glass, iron, raffia, other materials, H: 16 5/8", (42.2 cm). National Museum of African Art, Smithsonian Institution. Gift of Helen and Dr. Robert Huhn.

World Art Connections

• Aesthetically, the BaKongo minkisi n'kondi are an assemblage of eclectic objects. This concept associates well with the assemblage art of contemporary Western-European art. In assemblage art, an object is composed of fragments of other objects and materials originally intended for other purposes. Early examples of assemblage art in Europe date from the beginning of the twentieth century with the collages of Picasso and the found objects of Duchamp. Kurt Schwitters, Robert Rauschenberg, and Louise Nevelson also created three-dimensional collages or assemblages composed of objects found in daily life.

Schwitters, a German artist, created works of art from junk. He was a part of the Dada movement of the early twentieth century. His piece titled *Construction for Noble Ladies* (1919) includes bits of broken toys, wheels, boards, and assorted trash. The idea was to collect unrelated objects and juxtapose them for a provocative effect.

Rauschenberg also uses junk, but he specifically chose junk from urban life. In *First Landing Jump* (1961) he used whole objects, such as stuffed birds and automobile tires. Louise Nevelson creates sculpture from pieces of wood, including rough scraps, boards, and carved pieces of old Victorian houses. She arranges them in a screen format, as in her piece *Homage to the World* (1966), and then paints them a uniform color, usually black, to suggest the shadowy world of dreams.

What distinguished the work of Schwitters, Nevelson and Rauschenberg's work from that of the BaKongo? The Western artists used trash or junk, fragments of old things that have been discarded. The collection of objects that make up the aesthetic quality of the nkisi n'kondi figure is not junk. They were not discarded objects that were being reused, but objects created specifically for composing the nkisi n'kondi.

Nkisi may be activated by driving nails into the wood. Each blade represents an appeal to the forces represented by the figure. In some instances, when the request has been fulfilled the nails are removed.

Classroom Connections

• The BaKongo minkisi n'kondi were traditionally created through collaborative efforts of carvers and the ngangas. The concept of a collaborative product has been questioned by Western art historians who are trying to identify workshops where individual artists and their apprentices created nkisi figures with distinctive style.

Why might it be important to identify the objects by style? In the history of art, both Western and non-Western, are there examples of works being identified by studios, workshops, or guilds? Discuss with classmates the issues that are raised when attempting to identify artists of "unsigned" artworks. Think about the process involved in creating a nkisi figure. What you think the BaKongo would say to the issues raised?

Our knowledge of BaKongo history
begins with the establishment
of the Kingdom of the Kongo
in the fourteenth century.
The Portuguese were probably the first Westerners
to arrive in the kingdom.
This contact occurred in the fifteenth century.

Resources

Museums

Field Museum of Natural History, Chicago, Illinois

Fowler Museum of Cultural History, University of California at Los Angeles, Los Angeles, California

Menil Collection, Houston, Texas

Museum of Art, Carnegie Institute, Philadelphia, Pennsylvania

The National Museum of African Art, Smithsonian Institution, Washington, D.C.

University of Iowa Museum of Art, Iowa City, Iowa

University of Indiana, Bloomington, Indiana

University Museum, University of Pennsylvania, Philadelphia, Pennsylvania

Books

Cornet, J. *Art of Africa: Treasures from the Congo.* New York: Praeger Publishers, 1971.

Macaffey, W. "The Eyes of Understanding: Kongo Minkisi." In *Astonishment and Power.* Washington D.C.: National Museum of African Art, Smithsonian Institution, 1993.

- The BaKongo minkisi n'kondi are assembled works composed of many materials. List the various materials you can identify that were used to construct this nkisi. Each item is significant, not one item was arbitrarily chosen.

 Pick a theme that reflects something important in your life. Find an image in a magazine, cut it out, and photocopy it. Then transform the image by gluing additional images to it or drawing on it. Add pieces of materials you have collected or make rubbings and cut out sections to add to your image. Make sure that the elements you choose are connected to your theme. When you have finished your assemblage, photocopy it, and then write a paragraph at the bottom of the page identifying your theme and explaining why you chose the items displayed.

Study Sheet

1 How is the nkisi n'kondi constructed?

2 The nkisi n'kondi is an example of one "of the above." Why?

3 What materials on the nkisi n'kondi help reveal the unknown?

4 What do the words nkisi n'kondi mean?

9 New Media in African Art

The Link, III (1991)

Olubunmi Adejumo

OLUBUNMI ADEJUMO is a young Yoruba printmaker who draws his inspiration from African themes, particularly themes from traditional Yoruba culture. His images come from everyday Yoruba activities. He was born in 1959 in Ibadan, Oyo State, in the western part of Nigeria. Ibadan is the largest Yoruba city in Nigeria. Today he lives in Columbus, Ohio.

Adejumo comes from a long tradition of artists. His grandmother was a weaver of *aso-oke cloth,* a traditional hand-woven cloth used to make *iborun,* which is shoulder-wear worn by women to enhance their traditional attire. Adejumo's grandfather and other relatives were carvers. They designed houses and carved many of the house posts in the compound where Adejumo grew up.

Adejumo did not follow the traditional apprenticeship system. For the early part of his education he learned about art by observing relatives who made arts and crafts. As a youth he would practice drawing and chipping relief images on the mud walls of the compound. Later, he received his B.A. from the University of Benin in graphic design and a M.F.A. degree in printmaking from University of Massachusetts.

The Link III, Woodcut

Adejumo creates woodcuts using the **reduction method,** which entails cutting away negative spaces around the forms that will appear on the woodblock. Unlike most artists, who use separate printing blocks for each color, Adejumo uses one single block to create his multicolor prints. He starts his woodcuts by doing an initial drawing on a wood panel. The negative space is cut away and then the initial drawing is printed. The wood block is cleaned before the second round of cutting and printing begins. He continues this process until the entire print is complete.

Adejumo incorporates the wood grain into his prints. Notice the vertical patterns in *The Link III.* By using a single piece of wood to create his prints, Adejumo assures the consistency of the patterns formed by the wood grains. The idea of using a single block of wood to create a multicolored print is partly a result of his appreciation of wood's aesthetic qualities and learning the **calabash** carving techniques practiced by traditional Yoruba carvers. Yoruba carvers created relief patterns on the surfaces of calabashes and made wood sculptures from single blocks of wood.

There are a number of elements of Yoruba life and society that have influenced Adejumo's work, such as the hand-woven aso-oke cloth patterns, decorative *adire eleko* patterns, the **Oshun festivals,** and the **Egungun festivals.**

The aso-oke cloth incorporates rhythmic vertical lines that separate the various motifs in the weaving. Adire eleko, or indigo **resist-dyed cloth,** includes diverse linear motifs and geometric patterns. The cloth is dyed in different shades of indigo.

The Oshun festivals takes place annually in the Oshogbo region in Southern Yorubaland. These festivals are devoted to the commemoration of Oshun, **orisha** or sacred spirit of the waters of life and bestower of children. The concluding part of the festival takes place in groves where shrines to all Yoruba orisha are located. By attending this festival, Adejumo gained knowledge and understanding about the place of the orisha in the lives of the Yoruba people.

The Egungun ancestral festivals are held every spring in the Yoruba city of Abeokuta in southwestern Nigeria. This festival emphasizes ritual masquerade dances that invoke ancestral spirits who visit to bless or punish. The Egungun mask used in these rituals is a sign of the hunter. By attending this festival, Adejumo has experienced first-hand the traditional religious ceremonies.

It is these ceremonies and rituals that inspired the theme of *The Link III.* In this print, three overlapping and integrated heads fill the upper part of the composition. The largest head represents the head of the ancestor. The smallest head is the observer or individual who is interested in communicating with the spirits of the departed. The middle-sized head represents the drummer who is the link between the two. The lower part of the print gives the impression that the three heads are all sharing one body.

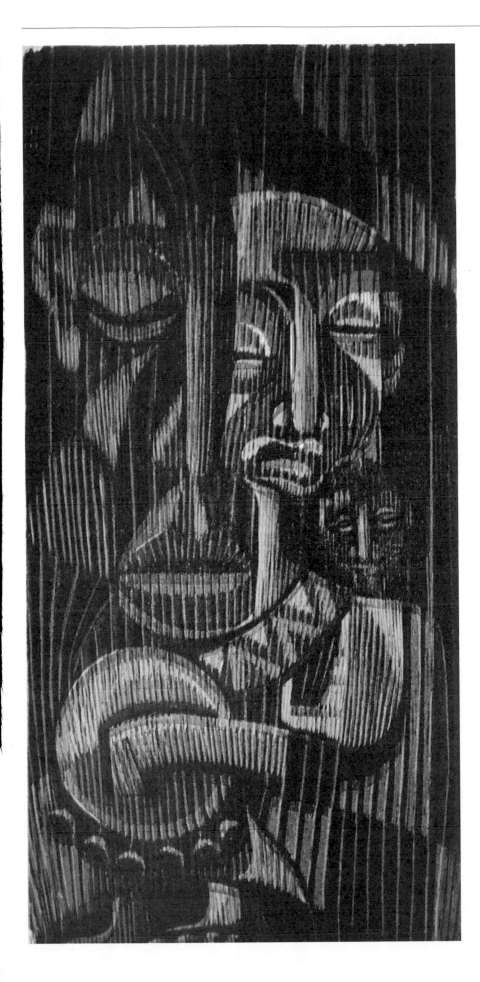

The middle figure has a drum hanging around his neck with his left hand extended to the center of the drum, as if he were in the process of playing. The drum is a "talking drum," which is used traditionally to communicate with the ancestors. It is large and conically shaped, with a double head that can imitate the human voice. The drum becomes the symbol through which a link with ancestors is possible, and also is associated with the idea of sharing the same body through the use of the drum, which is connected with the Egungun festivals. The title of the piece, *The Link III*, emphasizes one of the main purposes of the Oshun and Egungun festivals, which is to establish and continue the link between the living and the dead.

The linear vertical rhythmic patterns found in the print are inspired from the aso-oke cloth. Adejumo uses these patterns to create the slightly three-dimensional character of the facial forms. He also uses the linear patterns to fuse background and foreground, to create the flat space that surrounds the facial forms.

Notice the facial features: almond-shaped eyes, straight-bridged elongated noses, and full lips in the three figures. They were influenced by traditional Yoruba sculptures seen in the Oshun festivals, where the orisha shrines with their sculptural elements are displayed. The almond-shaped eyes, which are generally open in most Yoruba sculptures, are closed here to represent the sacred

Notice how Adejumo has used aspects of traditional Yoruba proportions in creating the figure of the drummer. Olubunmi Adejumo, *The Link III*, 1991. Woodcut. Photograph courtesy of the artist.

nature of the communication between the drummer and the spirit that the drummer is trying to get in touch with. The face of the drummer and the observer show facial markings that identify the family of the individuals.

Blues with tinges of grays and browns dominate the composition and are inspired by the indigo blue colors found in the Adire eleko cloth. Adejumo has used the brown tones to create contrast, to differentiate the forms, and to enhance the aesthetic quality of the print. Indigo is a royal color and indicates calmness and composure (itutu). Composure is necessary for one to have focus and to restrain power, characteristics considered necessary for one acting as the link between the living and the souls of the dead.

World Art Connections

• Woodcuts are the oldest form of printmaking. The Chinese used them to stamp patterns on textiles. The Romans used wood blocks to stamp symbols or letters on things for the purpose of identification. In the northern part of Europe in the 1400s, woodcuts provided multiple copies of religious images. Even though wood blocks were not used in Africa for printing, the calabash was. In Ghana the Akan people used calabash blocks to stamp prints on the Adinkra cloth in much the same manner as the Chinese.

Adejumo's color woodcut prints have the unique quality of being created out of one block of wood. Artists who use the wood block as a media seem to vary the technique, giving each woodcut unique qualities. In Japan, for example, where there is a long tradition of wood block printing, color woodcut prints are created from several blocks. Japanese artists have been known to use as many as twenty blocks for one woodcut. The printing was often completed by technicians who "translated" the artist's watercolor brush paintings into the blocks for printing.

The German tradition of woodcuts stems from Albrecht Dürer's work in the sixteenth-century and continues to the twentieth century with artists from the German expressionist period. Erich Heckel, for example, produced powerful woodcuts. He would print black outlines over painted areas. In *Portrait of a Man* (1919) the hands are painted olive green and the background is painted blue and brown before the print is applied.

Whereas Adejumo's prints deal with ritual and ceremonial themes, Japanese prints portrayed scenes from daily life. Those from the German Expressionist period tended to represent psychological states.

The images in Adejumo's works of art come from everyday Yoruba activities such as women pounding, musicians playing drums and horns, and ritual and ceremonial events.

Yoruba art past and present glorifies the relationship between the living and the dead. It reestablishes a spiritual link with the departed.

Study Sheet

1 Where does Adejumo generally draw his themes from?

2 Why is the woodcut titled *The Link III?*

3 How does the technique that Adejumo uses reflect aspects of traditional Yoruba carving techniques?

4 What is the purpose of the Egungun festival?

5 What elements of the Egungun festival can be found in the print *The Link III?*

Classroom Connections

• Look at Adejumo's print, noting the traditional Yoruba visual and cultural elements that he has included. Make a chart that shows the relationship between the visual elements and the cultural elements. Discuss what you have learned about Yoruba culture and society by studying Adejumo's print. Discuss the reciprocal importance of art and culture, the way art informs us about culture, and the way knowing something about a culture helps us interpret and appreciate its art.

• There are many ways of judging the quality of a work of art. Some say a work of art is good if it imitates nature or reality, others say it is good if the visual elements work harmoniously together. Some say a work of art must generate emotions and make you feel something special, while others believe a work of art is good only if it tells a story or makes a social statement. What do you think? Why? How would you judge Adejumo's print?

Resources

Museums
Benin City Mural Project

Ikoyi Hotel, Lagos, Nigeria

The Nigerian Paper Mills Jebba, Nigeria

Grazing at Shendi

Amir I. M. Nour

AMIR I. M. NOUR is a Sudanese sculptor who works in unconventional materials such as steel, cement, plaster, and molded plastic resins. As with many African artists who use contemporary materials to make their art, Nour draws his content from his tradition—his Nubian past and his Afro-Islamic background. He was born in Shendi a town in the Sudan, the largest country in Africa, which located between two steep rapids of the river Nile. This region is known as "the land of the White and Blue Niles" and has desert, savannah grasslands, hills, and tropical landscapes.

Nour's art is a part of a contemporary art movement that began in the late 1950s and sought to build on the best of traditional Sudanese art and crafts. The traditional sources of Sudanese art come from stone temples, Islamic architecture and calligraphy, decorative arts, and Nubian body painting. Artists who are a part of this movement take their artistic inspiration from these sources as well as from their cultural heritage, religion, and the geography of the Sudan.

Stainless Steel Sculpture

For *Grazing at Shendi*, Nour has used stainless steel because of its ability to withstand stress and resist collapse and corrosion. Nour was assisted by an aircraft company for the creation of this sculpture. The company made the semicircular units into two slightly irregular parts so that they would not be so geometric and could be joined together. Unlike normal stainless steel that reflects light, Nour wanted his pieces to absorb light. To achieve this he had them soaked in a solution of water, soap, and plastic pebbles for several days. This process dulled the surface and created the optical effect he wanted.

The sculpture is the best known of Nour's artworks because of its complexity. It is a series of forms put together to create semicircular units in various sizes. The strongest visual aspects of *Grazing at Shendi*, such as the sense of "timeless space," the repetitive forms, and the varying sizes, were all influenced by his Islamic heritage and the Shendi environment. Timeless space comes from Nour's visual experience of looking at the distant horizon of the Shendi sand and desert and seeing the activities of everyday life, such women accompanied by children, men collecting goat and sheep, and kneeling in prayer. These figures looked like dots in open space to Nour. The variation and repetition of the sizes of the steel semi-circular forms—some small, some medium, and some large—came from the observing forms on the sloping hills of the desert.

The semicircular shapes of the steel and the repetitiveness of that form might be inspired by an Islamic celebration known as *Id al Fitr*, which follows the end of Ramadan, the ninth month of the Moslem year when the faithful fast from sunrise to sunset. In this celebration, people dress in white and pray outside on their knees. Imagine what a multitude of people would look like in white, on bended knees. From a distance they might appear as white dots in space. Can you see how the repetition of the bended forms inspired the shapes of the sculpture's steel units?

The semicircular steel units that make up the *Grazing at Shendi* can be taken apart and reassembled. Each unit consists of two halves that are joined and placed on the ground. In all, there are 202 pieces. The placement of the pieces is not necessarily planned nor are they put into place by Nour. He allows

the sculptures to be assembled by others and does not dictate how they should be displayed or how each piece should relate to the other. He simply relays to the organizer what inspired him to create these pieces. That in itself helps give an orientation to the setup.

Nour is not concerned with creating realism, but is interested in spatial and visual geometry. Some say that this combination of spatial and visual geometry is a part of the Islamic heritage because in traditional Islamic civilization the artist and mathematician were

one. This synthesis of mathematics and design in contemporary Sudanese art can be observed most easily in the use of calligraphic motifs. Even though Nour does not appear to select his patterns from Islamic calligraphy, the curves of his semicircular steel forms recall calligraphic shapes.

Nour's work has been criticized for being non-African, because of his use of technology and the abstract quality of its forms. He justifies the use of his materials by aligning them with forms and shapes from his cultural environment. As for the abstract quality, Nour

reminds us that the Western world does not have a monopoly on abstraction, but that Muslim artistic heritage has always tended towards abstractions in the construction of traditional architecture and forms of Islamic calligraphy.

To break the monotony of the repeating semi-circular forms, Nour has varied the sizes of the steel pieces. Amir I.M. Nour, *Grazing at Shendi*, 1969. Steel (202 pieces), 119 3/4" x 161 3/4", (304.2 x 410.8 cm). Collection of the artist. Photograph by Franko Khoury, National Museum of African Art, Smithsonian Institution.

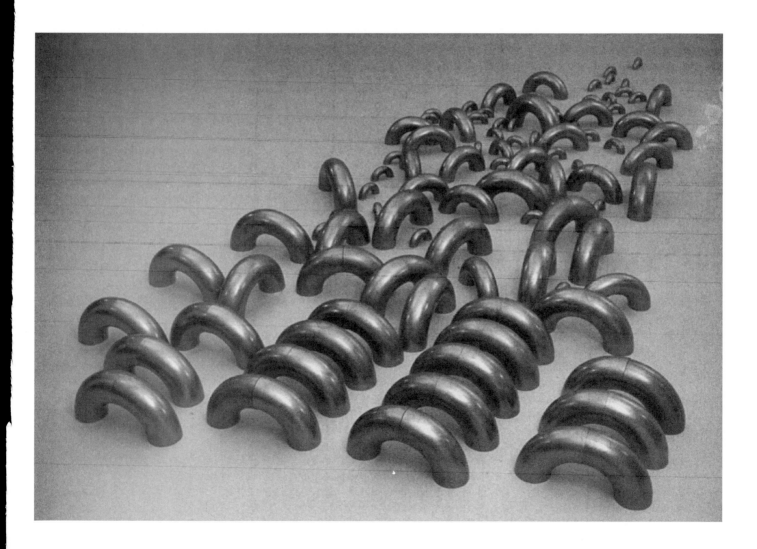

World Art Connections

• Nour's sculpture may be compared to minimalist art or primary structures movement in sculpture of the 1960s. It is similar in three respects: the materials used, how the pieces are made, and how they use space. One of the interesting aspects of Nour's work is that it is created in stainless steel and was fabricated in an aircraft factory, very much like the work of the American minimalist and environmental artists of the 1960s and 1970s.

It was probably the modern sculptor David Smith who was instrumental in introducing steel as a sculptural medium. Smith was welder-sculptor and learned these skills by working in a locomotive plant and automobile factory. Unlike Nour's, his sculptures were permanently assembled. Locate a reproduction of Smith's *Cubi XXIII*, which was part of a twenty-eight-piece series. *Cubi* (1964) was created out of cubes and rectangular boxes that were piled up and balanced with cylinders and disks.

The hallmark of metal sculpture in the 1960s and 1970s was the industrial aspect of making works in factories from plans made by the artist. Alexander Calder, known for his mobiles, set the example of using skilled industrial workers to manufacture finished works. Minimalist Donald Judd, for example, conceives the ideas for his work and then has master craftspersons execute his designs. Like Nour, Judd uses simple and undecorated forms made out of stainless steel. In his piece entitled *Stack*, (1969) Judd attaches ten identical quadrangular cubic masses of stainless steel equally spaced to a wall. Find examples of works by these artists and compare their use of metal and geometric forms with the work of Nour.

A difference between the primary structure movement of the 1960s and 1970s and Nour's work is in the forms and the inspirations for the works. Most of the European and American artists who followed this trend focused on angular geometrical shapes. Nour's sculptures has the distinguishing characteristics of using more organic forms.

Classroom Connections

• Nour does not assemble sculpture, but allows it to be assembled by others. He does not control the presentation, nor does he determine how the pieces should relate to the spectator or to each other. He simply shares his inspiration.

Make a series of geometric shapes or use already existing shapes like blocks, nails, tacks, or paper clips to construct a sculpture. Work in groups. Each group should have a different description of what has inspired the sculpture, such as a birds flying south, autumn leaves on the ground, animals in a landscape, or cars on a freeway. Place the sculptural pieces into an orientation that best fits the source of your inspiration. Take photographs of your sculptural creations and if possible mount the photographs beside pictures of the source of inspiration.

Nour comes from a region of arid, hot and dry land that was once part of ancient Nubia. The Nubians, a group of Negroid peoples, formed a powerful empire from the sixth to the fourteenth centuries situated between Egypt and Ethiopia.

Resources

Museums
Chase Manhattan Bank, New York City, New York

City of Chicago, Per Cent for Art Commission, Chicago, Illinois

The National Museum of African Art, Smithsonian Institution, Washington, D.C.

Books
Kennedy, J. *New Currents, Ancient Rivers: Contemporary African Artists in a Generation of Change.* Washington, D.C.: Smithsonian Institution Press, 1992.

Williams, S. H. Amir I.M. *Nour Sculpture,* Washington, D.C.: National Museum of African Art, Smithsonian Institution, 1994.

Amir Nour studied fine arts in Khartoum, Sudan at the School of Fine and Applied Arts. He continued his studies in the United States at the Yale University School of Art and Architecture.

Study Sheet

- Nour took his inspiration from daily activities of groups of people such as animals grazing, people praying, and women and children interacting. He translated his visual experience into sculptures. Think of everyday activities of groups of people, such as children playing, construction workers working, or football games. Working from a photograph or a drawing of these groups, translate the contours into simpler forms and recreate the spatial relationships between these forms. Then, using clay, recreate your visual experience into a sculptural form, expressing a sense of geometry.

1 What are sources from which some contemporary Sudanese artists draw their inspirations?

2 How did Nour produce a surface on metal that absorbed light?

3 Name at least two unique qualities about Nour's sculpture titled *Grazing in Shendi.*

4 How did Nour's environment influence his artwork?

Glossary

ade A Yoruba word meaning beaded crown.

adire eleko Adire refers to a technique used to dye cloth; adire eleko is a starch-resist technique.

agbaba A Hausa word meaning a man's gown.

amphora A tall jar with a narrow neck and base and two handles, used by Ancient Greeks and Romans.

aso-oke cloth Among the Yoruba this designates a hand woven cloth created by women.

attribute An object used in art as a symbol for a person, office or rank.

BaKongo The BaKongo are a group of people who live in large parts of Angola, the Congo and Zaire.

cache-séant A cloth that is used to cover the part of the body below the waist and above the knees.

calabash The dried hollow shell of a gourd used as a bowl or cup.

caliphate cloth An Islamic word that designates the cloth of a supreme ruler. It represents a prestige textile among the Hausa, Nupe and Northern Yoruba peoples.

Chama Ya Gohu A Mijikenda male title society which allowed members to acquire high status and gain authority through recognition of personal qualities and payment of entrance fees.

chi An Igbo term meaning spiritual essence.

cloisonné A type of enamel work in which the surface decoration is set in hollows formed by thin strips of wire welded to a metal plate.

cowrie shells A glossy shell found in warm seas. It was formerly used as currency in parts of Africa and south Asia.

cross-hatch A technique used in drawing that consists of two sets of parallel lines that cross each other.

crucifix A Christian symbol consisting of a cross with the figure of Jesus crucified on it.

diptych A picture divided into two panels.

diviner A prophet or person who can foretell the future or the unknown.

Egungun festival Egungun refers to masked dancers or performers who participate in festivals for the lineage ancestors. Egungun literally means masquerade.

emirate A title given to a ruler or prince in certain Moslem countries.

enamels Paints or varnishes that produce a smooth, hard, glossy surface when they dry.

Fang masks The Fang are a group of people who occupy large parts of Southern Cameroun, equatorial Guinea and Northern Gabon. Their masks have oblong white faces with arched eyebrows that continue into elongated lines of the nose.

Fetish An object believed to have magical power.

figurative pottery Pottery that takes the form of a human figure or has parts that are related to a human figure.

Gala blanket A blanket with beaded trim worn by Ndebele women during ceremonial and celebratory occasions.

gypsum A mineral that has hydrous calcium sulfate that is used to make plaster of Paris.

ibol An object carved in full relief and placed before the Kuba ruler's statue to symbolize his reign.

iborun A Yoruba term referring to a woman's shoulder cloth.

ichi marks An Igbo term referring to marks of ritual purification.

icon A conventional religious image, generally painted on a small wooden panel.

ikenga An Igbo term for a personal shrine. It refers to a carved wooden statue thought by the Igbo peoples of Nigeria to ensure good fortune.

initiate Those who are to be incorporated into a group in society of which he or she was previously not a member.

kapok The silky fibers around the seed of several tropical trees. The seeds are used for stuffing mattresses, life preservers and sleeping bags.

kaya A word used by the Mijikenda people to describe a sort of enclosure that served at one time as a fortress retreat.

kigangu A word used by the Mijikenda people to describe memorial posts. Vigangu is the plural of this term.

kraters A jar or vase of classical antiquity with a large, round body, wide mouth and small handles.

Kule A Senufo term meaning an individual who belongs to the artisan caste of woodcarvers.

latex A milky-white fluid that comes from cells of seed plants used in paint and adhesives.

madebele A Senufo term meaning living bush spirits that reside in the fields, streams and wooded areas.

Mangbetu A group of people who live in Northeastern Zaire.

masquerade A social gathering in which dancers wear masks and costumes, and perform to music and song.

matrilineal society A society based on tracing descent through the mother's line.

mosaic A surface decoration made by inlaying small pieces of variously colored materials to form pictures or patterns.

motif A single or repeated design in a work of art.

mural A painting applied to and made integral with a wall surface.

nkisi n'kondi The nkisi n'kondi is an example of a figurated medicine. Nkisi means nature spirit or sacred medicine while n'kondi means hunter. The two words together signify a nkisi "of the above," one that is associated with the earth and the waters. Its job is to maintain public order, seal treaties and identify and punish criminals.

nganga A Kikongo term that designates the person who makes and dispenses medicines; an herbalist.

ntadi A Kikongo term meaning stone image. Mintadi is the plural form of the word.

Oba A Yoruba term for king.

oracle A medium by which a spirit is consulted or any agency believed to communicate with the spirit world.

oriki A Yoruba term designating a praise song or poem.

orisha A Yoruba term that refers to a group of deities. Some of these deities at one time had an earthly existence and because of some extraordinary deed became deified after they departed the earthly realm.

Oshun festival A Yoruba festival that honors the orisha of the waters, Oshun. Oshun is the most important of the female orisha. She is responsible for enabling women to bear children and saves her followers from diseases of the flesh, like smallpox.

paganism A term that refers to beliefs that are not Christian, Moslem or Jewish.

patina A fine crust or film that coats an artwork, changing its color.

patrilineal society A society based on tracing descent through the father's line.

polychrome Related to, made with or decorated in several colors.

pediment sculpture Refers to sculptures found on a low-pitched gable or triangular-shaped piece, on the front of some buildings in Greek architecture.

reduction method A method of carving or engraving where areas that are not meant to print are cut and gouged out so that the image stands out in relief.

relief A form of sculpture in which details, ornaments and figures project out from the surrounding plane surface.

resist-dyed cloth A dying process whereby parts of a cloth resist the dye because it has been treated with wax, starch, rocks, stitches or other means of blocking the penetration of the dye.

Sangogo association A powerful Senufo women's association that is responsible for safeguarding the purity of the matrilineage and maintaining good relationships between the bush spirits and the general population through divination.

scarification Linear scars cut in grooves or in relief.

sinew The dense white fibrous connecting tissues that unite a muscle that can be used as thread.

slip Ceramics clay thinned to the consistency of cream for use in decorating.

steatite A talc (soft mineral) rock that can be whitish, greenish or grayish with a soapy feel to it.

stucco Material made of portions of cement, sand and lime. It can be used to cover and decorate exterior or interior walls.

talisman An object that has a sign and acts as a charm to keep evil away and bring good fortune.

tambari A spiral embroidered motif found on the Hausa Robes of Honor. It means "kings drums" and is a part of the emirate's insignia of power.

terra cotta Unglazed fired clay used for making statuettes and vases.

triptych A picture divided into three panels.

uli An Igbo term that refers to cursive patterns created from indigo or black pigments that were used on houses and worn by men as ornaments.

African Pronunciation Guide

Abeokuta (ah-Bay-o-koo-tah)

Adire eleko (ah-Dee-ray ay-le-ko)

Afon Alaiye (eh-fon uh-lie-yuh)

Amir Nour (Ah-meer Nor)

Arinjale (AH-rin-JAH-lay)

aso-oke (AH-shur-o-kay)

BaKongo (Bah-KON-go)

Benin (beh-NEEN)

cache-séant (cah-sha say-ant)

caliphate (Cah-LEE-fate)

Chama Ya Gohu (CHAH-mah yah go-hoo)

chi (CHEE)

Chibinda (CHEE-been-dah)

Chokwe (CHOH-kway)

Cikungu (Cee-koon-goo)

cipenya (CEE-pen-yah)

Dhu l'Fakar (DHOO l'Fah-kar)

Duga of Meko (DOO-gah of Meh-koh)

Edo (Eh-DO)

Egungun (E-goon-goon)

gelede (GEH-leh-day)

Giriama (gee-REE-a-ma)

girke (GEER-keh)

Hausa (HOW-sah)

Ibadan (EE-bah-dan)

Ibol (EE-Bohl)

iborun (EE-boh-roon)

ichi (EE-chee)

Id al Fitr (Eed-EL-Fee-tre)

Igueghae (EE-goo-ay-gha)

igbo (EEg-bo)

ikenga (EE-kehn-gah)

Igala (ee-GAH-la)

jocolo (jah-CAH-lah)

Kano Emirate (KAH-no EH-meer-ate)

Kauma (Ka-OO-ma)

ketu (KEH-too)

Kigangu (kee-GAHN-goo)

Koma (KO-mah)

Kongo (Kon-go)

Kuba (Koo-ba)

kule (KOO-lay)

Luba (LOO-ba)

Lueji (LOO-ey-zee)

Luunda (loo-ON-dah)

madebele (ma-DAY-bay-lay)

Mangbetu (May-ng-BEH-too)

Mani Kongo (MAH-nee KON-go)

Maputo (muh-POOT-o)

Mbope Mabiintshi ma-Kyeen (mm-BAH-pay Mah-been-t-shee mah-kyeen)

mentsi (MEHN-t-see)

Mijikenda (mee-gee-KEHN-da)

milingakobe (mee-LEENG-a-koh-bay)

Misha mi-shyaang a-Mbul (mee-shah mee-shy-ayng ah-mbool)

Mushenge (moo-Shehn-geh)

mutwe wa kyanda (MOO-tway wah Key-AHN-da)

Ndebele (nn-deh-beh-leh)

Ndop (nn-DOHP)

nganga (nn-GAHN-ga)

ngurara (nn-GOO-rah-rah)

nkangi (nn-KAHN-gee)

nkisi (nn-KEE-see)

nkisi n'kondi
(nn-KEE-see n KON-dee)

Ntadi [Mintadi]
[meen-TAH-dee]

Oba (O-ba)

Obalufon (O-bah-loo-fon)

ode (O-day)

Oduduwa (oh-doo-DOO-wah)

Ogun (O-goon)

Oguola (O-goo-o-la)

okin (AH-keen)

Okondo (Oh-KOHN-do)

Olokun (O-lah-koon)

Olowe of Ise (OH-lo-way of EE-say)

Olubunmi Adejumo
(Oh-loo-BOON-mee AH-day-joo-mo)

Oni of Ife (O-nee of EE-fay)

Oro Efe (O-RO AY-fay)

Osemwede (O-seem-way-day)

Oshogbo (AH-shog-boh)

Oshun (AH-shoon)

Oyo (Or-yo)

pepetu (PEH-peh-too)

riga (REE-guh)

Sangogo (Son-go-go)

Senufo (SEHN-noo-fo)

uli (oo-LEE)

Yoruba (YOH-roo-ba)

Index